Remembering

Texas Lawmen

Mike Cox

TRADE PAPER

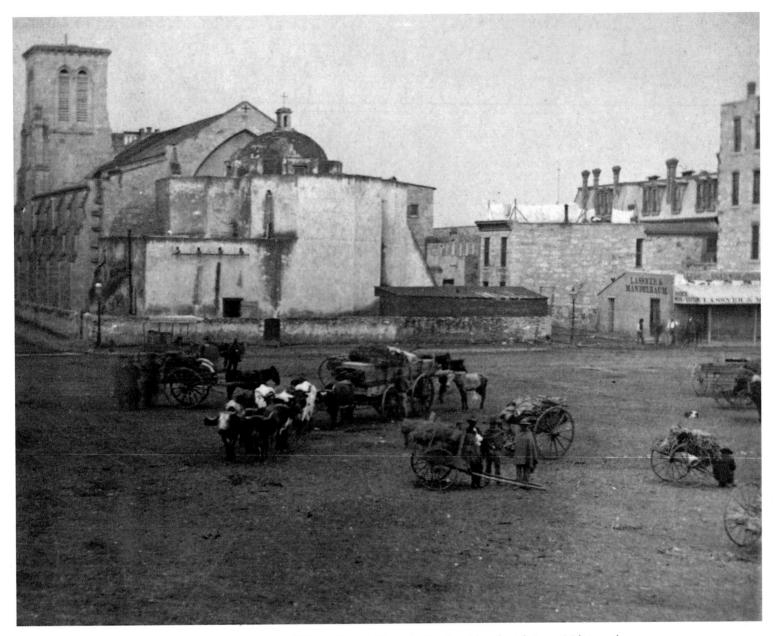

The commercial and martial heart of San Antonio was Military Plaza, laid out during Spanish colonial times. Militia and Ranger units mustered here for generations. The plaza was also home to the city's chili queens, pioneers of Tex-Mex food. This image was recorded in 1875.

Remembering Texas Lawmen

445 Park Avenue, 9th Floor New York, NY 10022 Phone: (212)710-4338 Fax: (212)710-4339

200 4th Avenue North, Suite 950 Nashville, TN 37219 Phone: (615)255-2665 Fax: (615)255-5081

Remembering Texas Lawmen

www.turnerpublishing.com

Copyright © 2010 Turner Publishing Company

All rights reserved.

This book or any part thereof may not be reproduced or transmitted in any form or by any means, electronic or mechanical, including photocopying, recording, or by any information storage and retrieval system, without permission in writing from the publisher.

Library of Congress Control Number: 2010932275

ISBN: 978-1-59652-702-7

Printed in the United States of America

10 11 12 13 14 15 16—0 9 8 7 6 5 4 3 2 1

CONTENTS

ACKNOWLEDGMENTSVII
PREFACEVIII
CHAPTER ONE
(1849–1879) 1
CHAPTER TWO
(1880–1899)
CHAPTER THREE
(1900–1919) 65
CHAPTER FOUR
(1920–1940)93
NOTES ON THE PHOTOGRAPHS130
BIBLIOGRAPHY134

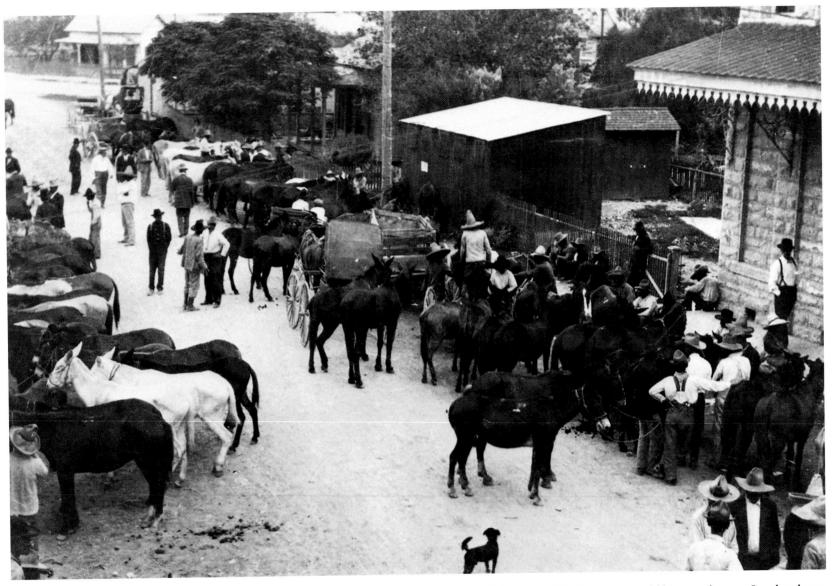

A view of Del Rio in the late 1890s. Though a small community, being on the Rio Grande, it could be a rough town. Local and state lawmen had to deal with criminals from both sides of the border.

ACKNOWLEDGMENTS

This volume, Remembering Texas Lawmen, is the result of the cooperation and efforts of many individuals and organizations. It is with great thanks that we acknowledge the valuable contribution of the following for their generous support:

Dallas Public Library
Institute of Texan Cultures
Library of Congress
Mike Cox
University of Oklahoma—Western History Collections

With the exception of touching up imperfections that have accrued with the passage of time and cropping where necessary, the photographs have not been altered in any way. The focus and clarity of many images is limited to the technology of the day and the skill of the photographer who captured them.

PREFACE

The history of Texas law enforcement considerably predates photography. When Spain first began settling what would become the Lone Star state, its soldiers amounted to Texas' first peace officers. But they handled every problem, from protecting the missions from hostile Indians to maintaining civil order. The first known Texas lawman was 26-year-old Vicente Alvarez Traviesco. He was appointed *alguacil* (sheriff) of San Antonio de Bexar in 1731.

In 1821, empresario Stephen F. Austin brought 300 American colonists to Texas, by then a Mexican province. Austin tried to pick his immigrants carefully, but even with character references, a few troublemakers made it to Texas. Thomas V. Alley was appointed constable by John Tumlinson on March 5, 1823, and is considered Texas' first colonial peace officer. His job was to act "in the capacity of constable to summon witnesses and bring offenders to justice." Later that summer, Austin wrote that he planned to hire ten men to act as rangers for the common defense of the colony. That is considered the genesis of the Texas Rangers, though their job principally involved protecting the settlers from hostile Indians, chiefly the fierce Kawakawa.

When Texas became an independent republic in 1836, its constitution called for the election of a sheriff for each of its 13 original counties as well as "a sufficient number of constables." Sheriffs were charged with serving civil process, with keeping the peace, quelling and suppressing "all affrays, riots, and unlawful assemblies," as well as pursuing, apprehending, and jailing "all persons charged with crime." Often, sheriffs also levied and collected taxes. Though vested with considerable power, being sheriff was not an easy job. In Harrison County, ten men held office during the time of the republic, an average of about one man a year. One sheriff vacated his office when a lynch mob hanged him and burned his tax book. In 1836, President Sam Houston appointed San Jacinto veteran Robert J. Calder as marshal of the new republic. But the job description was different from what the title would suggest. The marshal's primary duty was to take charge of and oversee the disposition of shipwrecks or prizes seized by the nation's navy. Calder did not hold that job long before being elected sheriff of Brazoria County, where he served three terms.

Following Galveston's incorporation in 1839, Leander Westcott became its first marshal. Drawing a \$1,500-a-year salary, he received \$600 to hire two deputies. The hulk of the *Elbe*, a storm-wrecked vessel, served as the island city's first jail. Houston incorporated in 1837 with G. W. Holland elected as its first constable. But the Bayou City, though rowdy, was a much smaller town than bustling Galveston, the republic's largest city. Houston would not have a city marshal until 1841 when Daniel Busley was appointed.

After nearly a decade as a nation, Texas joined the Union in 1845. Its new constitution retained both the office of sheriff and constable at the county level while a state statute allowing for municipal government gave local officials the power to appoint town marshals. When San Antonio incorporated in 1846,

the town council appointed James Dunn as the city's first marshal that January 14. Texas' new status as the 28th state triggered the 1846-1848 Mexican War. During that war, the first known Texas photograph was taken. Fittingly, the image captured by daguerreotype was a view of the Alamo. In 1851, the capital city got its first full-time marshal. Two years later, the federal government assigned a U.S. Marshal to Austin, former Ranger Ben McCulloch.

For the most part, law and order departed Texas during the Civil War. While the state escaped major battles on its own soil, as the war progressed, civil order steadily deteriorated. Many Texas counties had no sheriff or constables and few cities could keep a marshal employed. During Reconstruction, occupying forces handled what passed for law enforcement. On June 8, 1867, Major General Charles Griffin dismissed the entire Galveston police force and appointed 25 of his own hand-picked men, including five blacks. Though unpopular with local residents at the time, that gave Galveston the distinction of having Texas' first integrated law enforcement agency. Elsewhere in the state, in many counties the offices of constable and sheriff stood vacant for several years during this turbulent period. Even had there been a sufficient number of lawmen, only 82 counties had jails.

Some stability resumed with the creation in 1870 of the Texas State Police, a uniformed force. The following year its 160-plus officers made 3,602 arrests. But the force, tightly controlled by Governor E. J. Davis, operated with a heavy hand. On April 22, 1873, the legislature passed a law abolishing the state law enforcement agency. For a year, law enforcement again rested solely in the hands of sheriffs, constables, and marshals in the more populated towns and cities. But in 1874, the legislature reconstituted the Texas Rangers as the Frontier Battalion, the state's first permanent Ranger force. Though still primarily occupied with Indian-fighting, for the first time Rangers had statutory authority as law enforcement officers. Two years later, Texans adopted a new state constitution, a document retaining the strong authority accorded county sheriffs since the days of the republic. Every two years, voters got to pick a new sheriff, but some men served numerous terms.

By the 1890s and continuing into early decades of the twentieth century, the larger cities began organizing police departments with appointed or elected chiefs. One of the first cities to switch from having a marshal to a police department headed by a chief was El Paso, where on August 16, 1889, the city's council appointed T. C. Lyons as chief. Uniformed urban officers still patrolled their beats by foot and horse, but by 1910 most departments began using automobiles and two-wheeled motorcycles.

As Texas grew and became more urbanized, so did its law enforcement. In addition to uniformed beat cops, the larger departments added plainclothes men as detectives. To aid in crime solving, by 1915 most of the larger police departments had started collecting and filing fingerprints and photographing those arrested. When commercial radio stations began going on the air in the early 1920s, as a public service they broadcast police calls. Austin became one of the last major Texas cities to convert from a city marshal's office to a police department, the change coming in 1928. J. N. Littlepage, the last marshal and first chief, was soon shot to death trying to disarm a man who had just shot five other people. Indeed, law enforcement in Texas did not come without a price. Through 1934, at least 752 law enforcement officers—rangers, sheriffs and their deputies, constables and their deputies, marshals and their deputies, and state and city police officers—gave their lives in the line of duty to help make Texas a safer place to live, raise a family, and work.

-Mike Cox

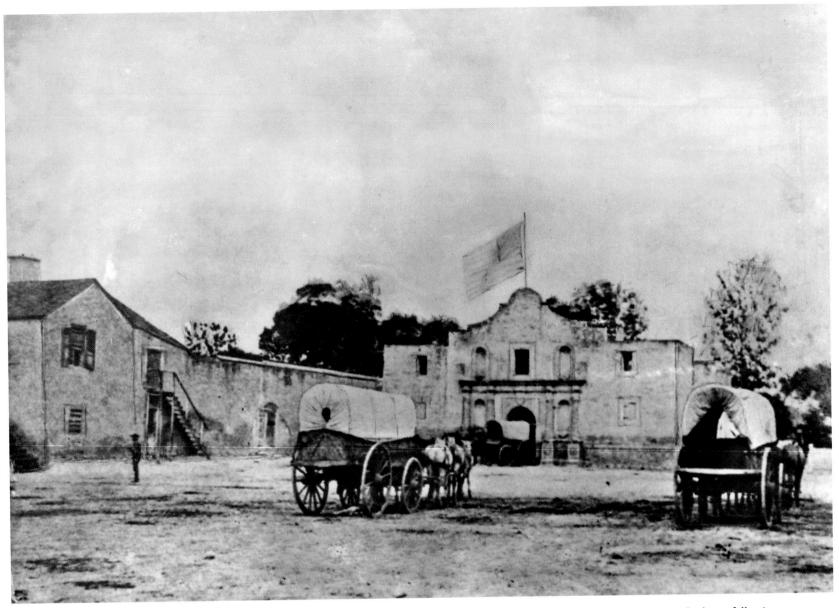

One of the earliest known Texas images, this photograph of the Alamo was taken after the U.S. military converted it into an Army supply depot following Texas' admission as the 28th state. San Antonio law enforcement at the time depended on the Bexar County sheriff and a city marshal.

CHAPTER ONE

(1849 - 1879)

Ben McCulloch fought at the Battle of San Jacinto in 1836 and rode as a ranger with Jack Hays. In 1853 he was appointed as a U.S. Marshal and stationed in Austin.

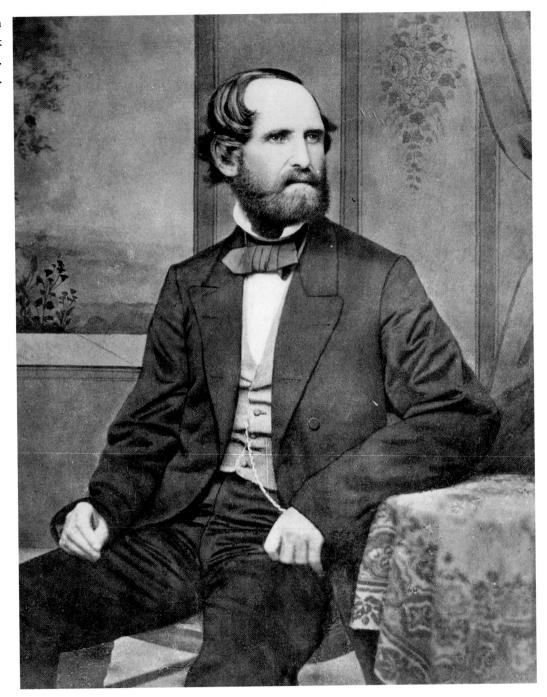

Asa Jarmon Lee Sowell (1822–1877) came to Texas with his family when he was eight years old. In 1839, he served with his two older brothers in Matthew "Paint" Caldwell's Gonzales Rangers and later as chief justice (roughly equivalent to a modern county judge) of Guadalupe County. His son also would sign up as a Texas Ranger.

One-eyed Eustace Benton (1839–1914), was a nephew of Ben McCulloch and his brother Henry, both rangers.

When only 16, while riding as a ranger in a company commanded by his father, Benton took a bullet in his right eye. It happened during the 1855 Callahan expedition, a Ranger pursuit of hostile Indians into Mexico. Though the wound resulted in the loss of some brain matter, the young ranger recovered. He later served with distinction in the Confederate army, finally settling in Arkansas.

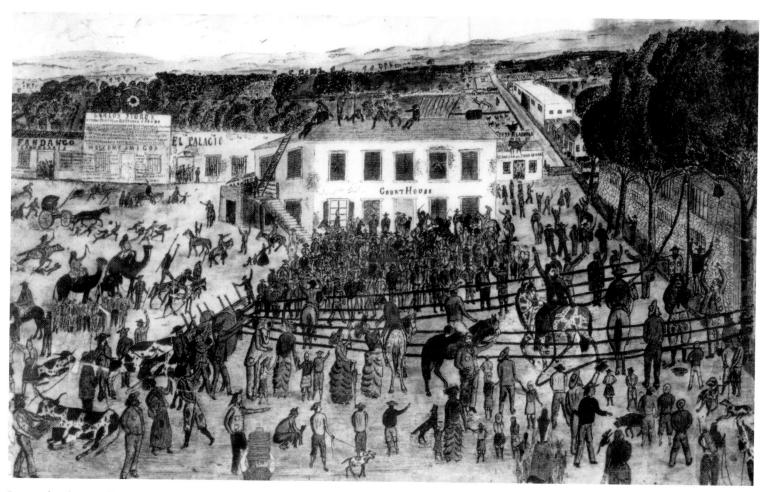

Law and order rapidly eroded in Texas after the state joined the Confederate cause, leading to a rise in vigilantism. One victim of mob law was Bob Augustine, strung up in San Antonio. A well-dressed dandy with a weakness for booze and pretty ladies, he got drunk one day and greatly disturbed the peace. When on September 9, 1861, a sympathetic city judge acquitted him on the misdemeanor charge resulting from his spree, a delegation of citizens snatched the unfortunate Augustine and hanged him from an elm tree. They viewed it as a warning not only to other miscreants, but to what they considered a lax local law enforcement community.

Andrew Jackson Sowell, whose father rode with Ranger Captain Jack Hays, served as a ranger in 1870-71. In 1884, he included his experiences in Rangers and Pioneers of Texas, with a Concise Account of the Early Settlements, Hardships, Massacres, Battles and Wars By Which Texas Was Rescued From the Rule of the Savage and Consecrated to the Empire of Civilization. Despite its ponderous title, Sowell's book became a Texas classic.

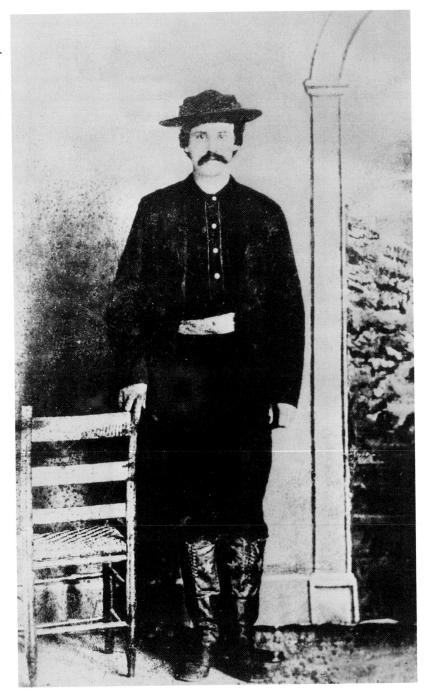

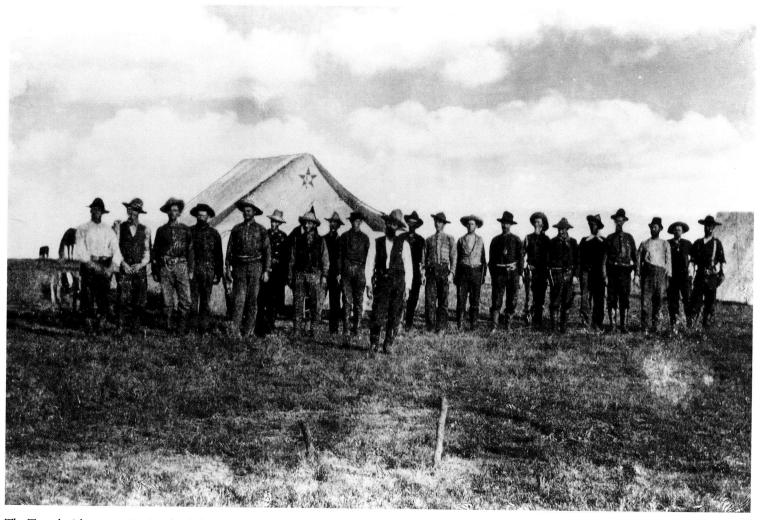

The Texas legislature institutionalized the Texas Rangers in 1874 with the creation of the Frontier Battalion. Though concerned primarily at first with Indian-fighting, the Rangers were also vested with law enforcement authority for the first time in their history. This is believed to be Company B sometime in the mid-1870s.

Pat Dolan first joined the Rangers in 1870, serving through most of 1871. Then he got elected as sheriff of Uvalde County, serving from 1872 to early 1876, when he enlisted in the Rangers again. He rose in rank to lieutenant and then captain. Later he operated a ranch in the Big Bend and, from 1888 to 1890, held office as Jeff Davis County sheriff.

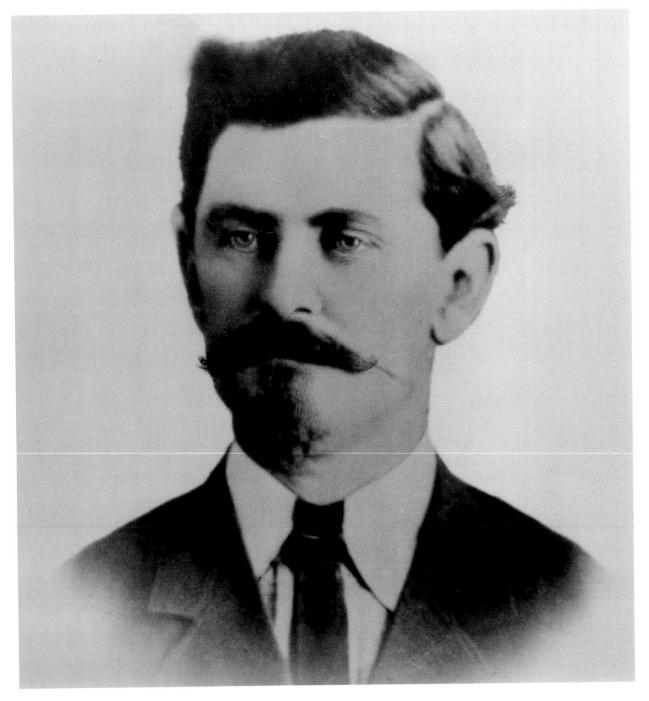

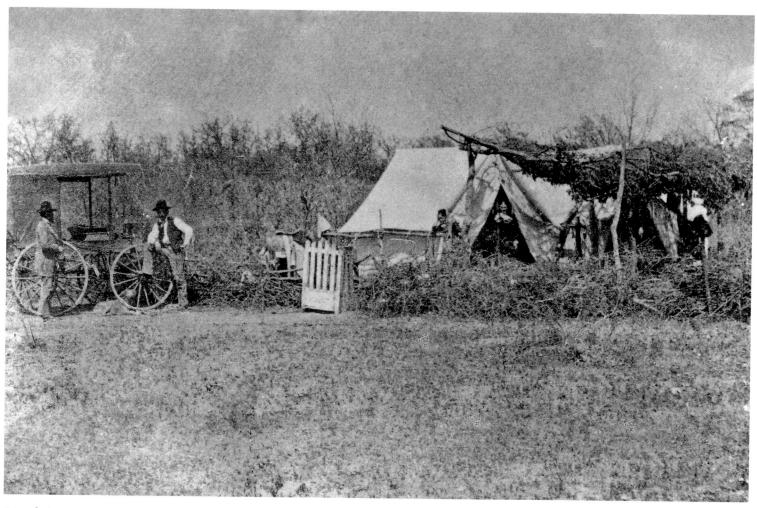

Dignified with a white picket gate (perhaps someone's idea of a joke?), this tent and brush arbor served as quarters for Ranger Captain Daniel Webster Roberts for a time in 1876. He is standing at the wagon next to his sergeant, Lam P. Sieker.

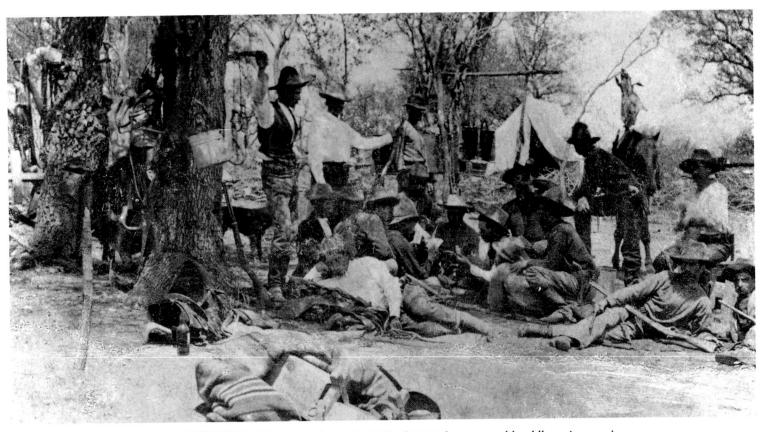

Despite relaxed conditions evident in this 1878 photograph of a ranger camp, the state lawmen could saddle up in pursuit of Indians or outlaws at a moment's notice.

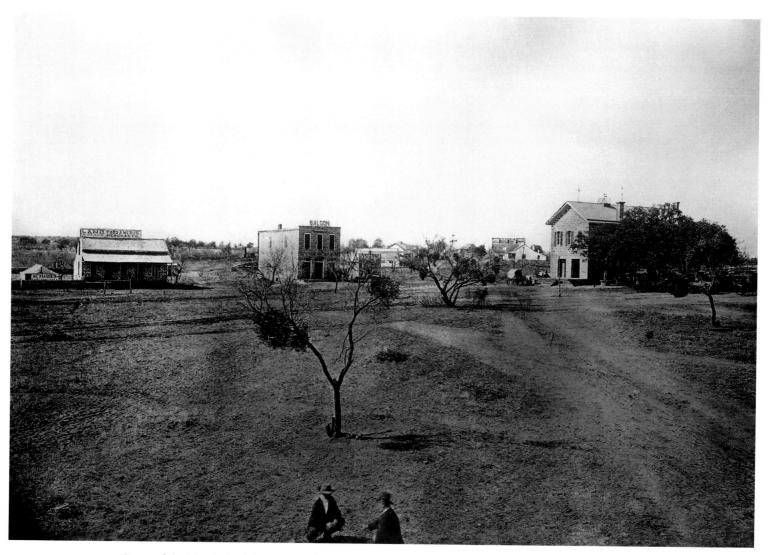

Scene of the bloody feud that came to be called the Hoo-Doo War, this is a view of the town of Mason in 1876. At the peak of the hostilities, which brought in the Rangers, the sheriff of Mason County found it expedient to leave for parts unknown.

Like many early Texas gun toters, John Selman seemed to have trouble deciding which side of the law to uphold. Around Albany in West Texas he helped protect his community as an Indian fighter, but he drifted into cattle rustling and outlawry. But at the age of 52 in 1892, he got elected city constable in El Paso and began lowering the crime rate by shooting folks he thought needed killing.

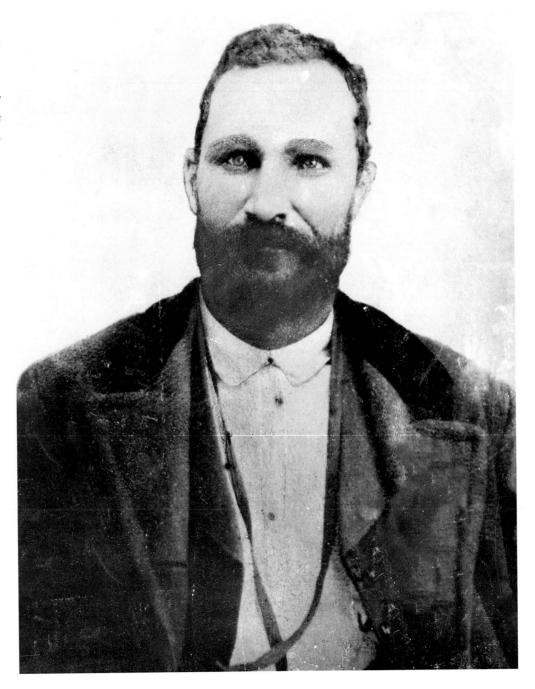

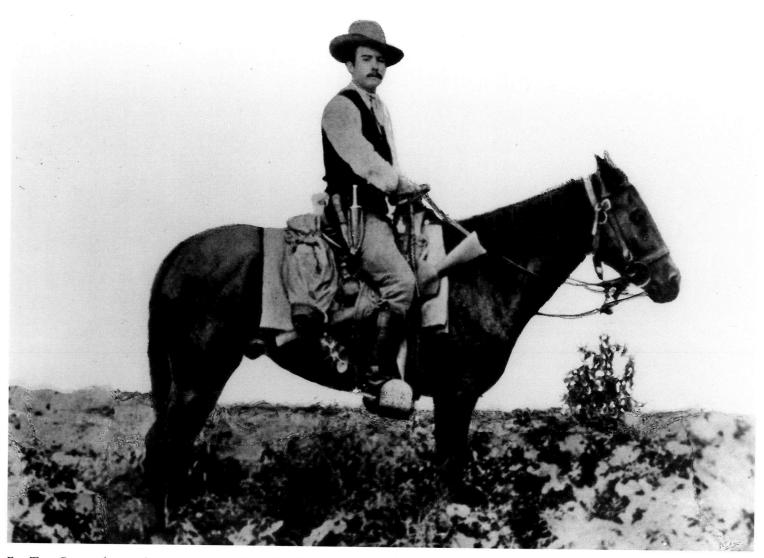

Few Texas Rangers became better known than James B. Gillett, shown here on his horse, Duty, in 1878. Gillett joined the Frontier Battalion in 1875 and served as a ranger until 1881. He later wrote one of the classic histories of the Old West, Six Years with the Texas Rangers.

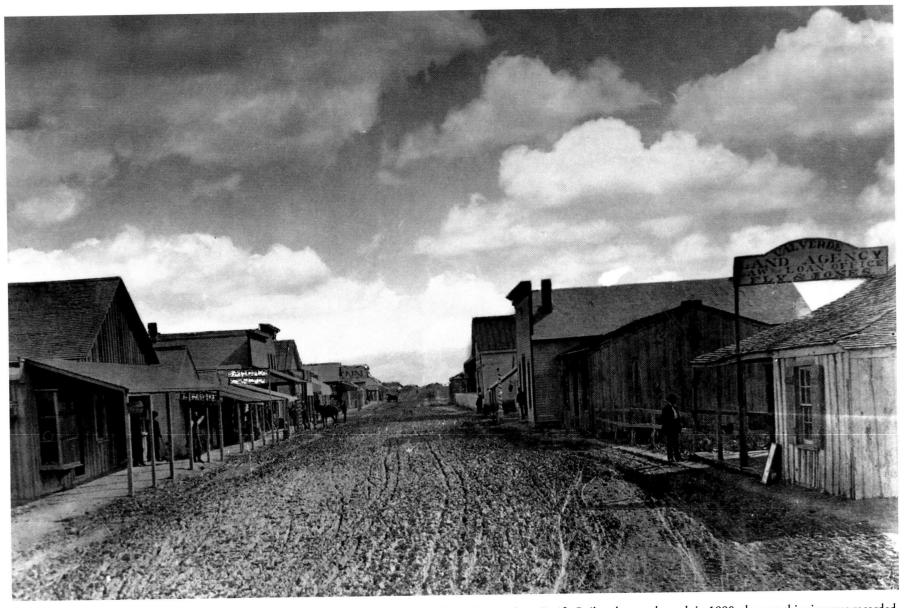

The border town of Del Rio boomed after the Southern Pacific Railroad came through in 1880, the year this view was recorded.

CHAPTER TWO

(1880-1899)

When the legislature created Morris County in north Texas in 1875, Aurelius Ragland was elected as its first sheriff. A Confederate veteran, Ragland held office until November 4, 1884. He died at 52 on August 8, 1898.

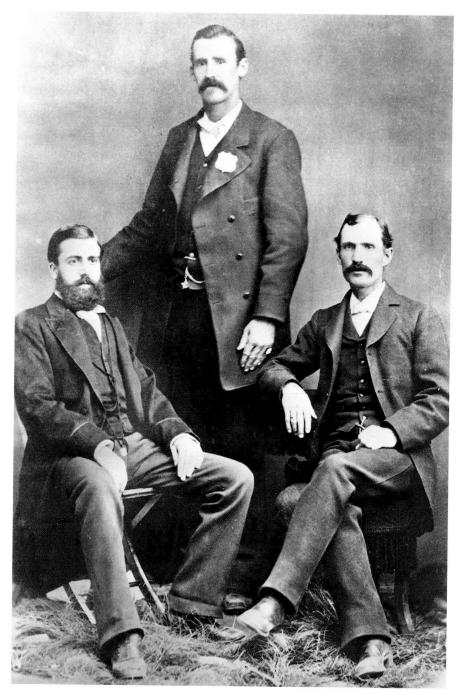

Former Ranger Dallas Stoudenmire, standing at center, as good with a gun as he was at consuming large quantities of whiskey, became El Paso's city marshal in 1881. Four days after pinning on his badge, he participated in a deadly gun battle that left four people dead in five minutes. His drinking finally cost him his job, but he soon got hired as a deputy U.S. Marshal.

When Jim Gillett left the Rangers, he hired on as deputy city marshal in El Paso under Dallas Stoudenmire. After Stoudenmire's forced resignation, city fathers appointed Gillett as his successor. This image shows the new marshal in the Senate Saloon in 1881. From the left: Harry Matthews, a seated Gillett wearing a fancy white bowler, saloon owner George Speck, and two bartenders. A year later, Gillett arrested his former boss following a shooting affray and less than two months later investigated the hard-drinking Stoudenmire's fatal shooting.

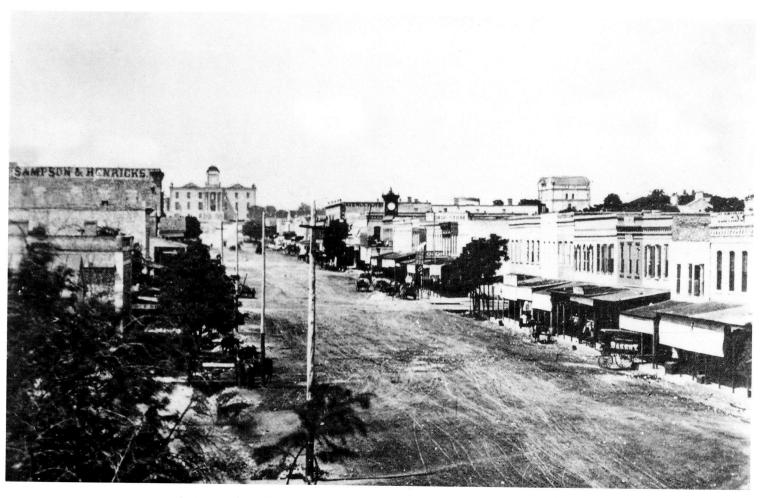

A view north up Congress Avenue in Austin around 1880. On November 9, 1881, fire gutted the limestone capitol shown at the top of the photograph. The building also served as headquarters for Adjutant General John B. Jones and the Frontier Battalion he commanded.

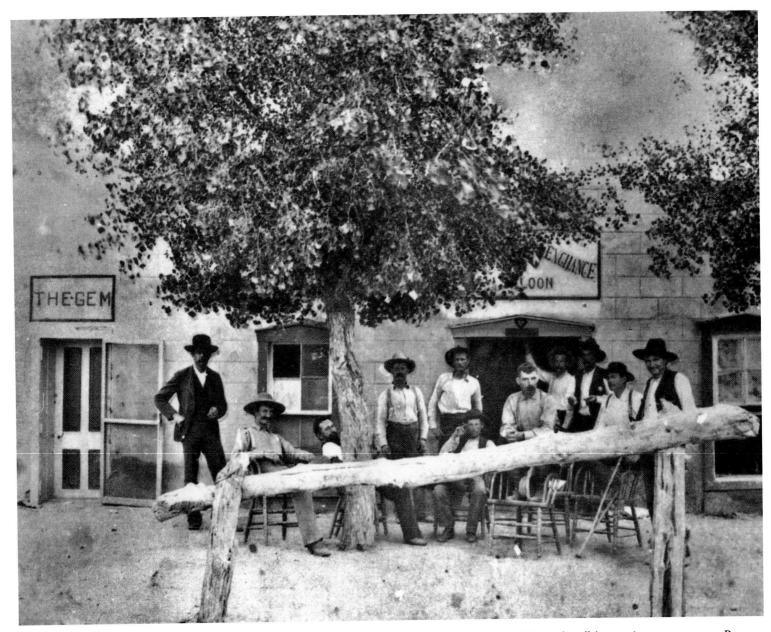

Now a ghost town, Tascosa for a time in the early 1880s ranked as one of the Panhandle's most important towns. Rangers backed up Sheriff Cape Willingham in maintaining law and order in that remote part of the state. The identity of these rangers, shown standing in front of a saloon, has been lost.

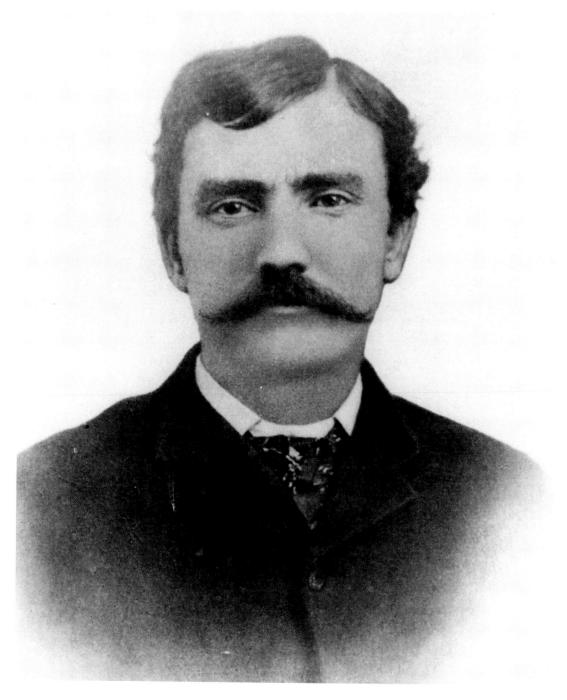

A cattle rustler and outlaw once pursued by rangers, John "King" Fisher became a Uvalde County sheriff's deputy in 1881, and two years later he was named acting sheriff. He planned to run for a full term, but on March 11, 1884, he and his pal Ben Thompson, former Austin city marshal, died in a flurry of gunfire in the late Jack Harris' theater in San Antonio. While Thompson's death went down as payback for killing Harris, Fisher just happened to be in the wrong place at the wrong time.

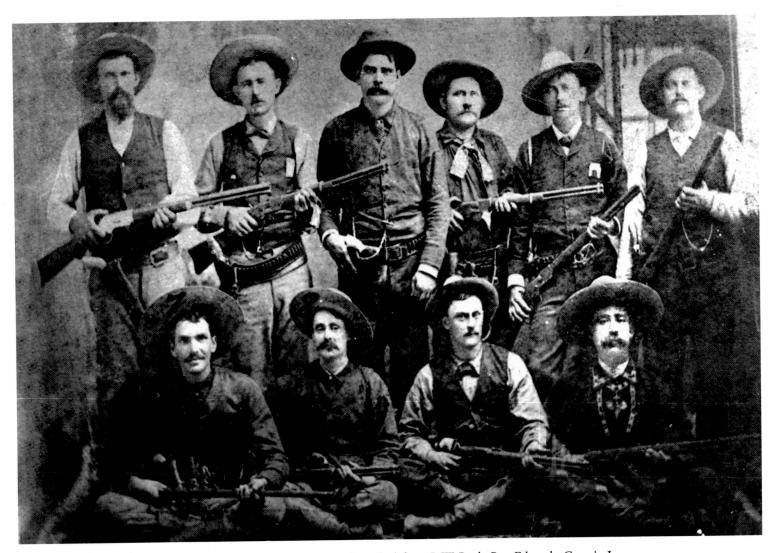

Frontier Battalion Company F, photographed in 1882. Clockwise from the left are J. W. Buck, Pete Edwards, Captain Joe Sheely, George Farrer, Brack Morris, Charlie Norris, Wash Sheely, Tom Mabry, Bob Crowder, and Cecilio Charo. Ranger Morris later became sheriff of Karnes County, dying in the line of duty in 1901.

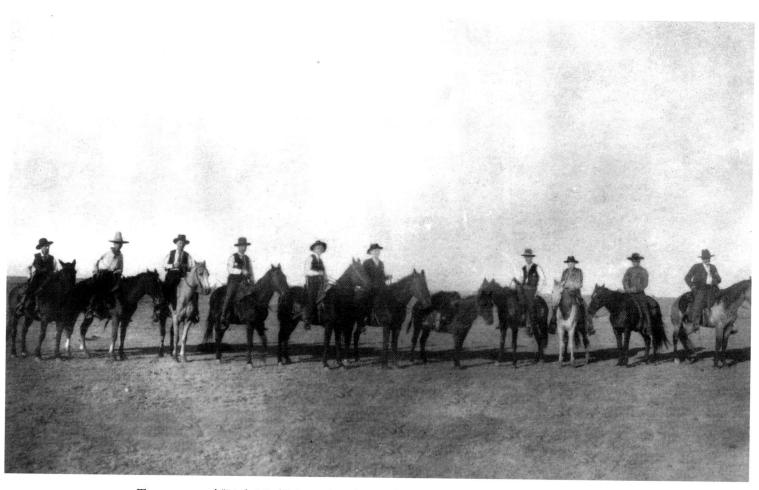

Ten rangers and "Little Mack" the pack mule pose for a group shot in 1882. Brothers Tom and S. M. Platt served briefly in the company from June 1 to August 1882.

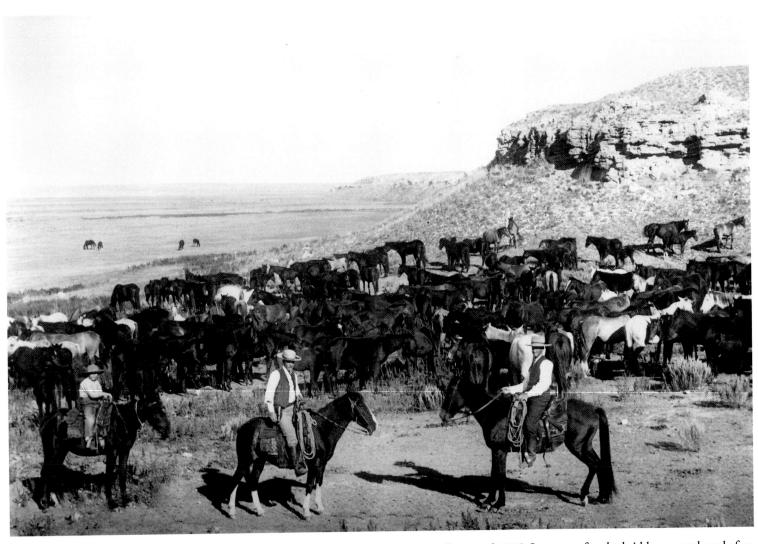

Two cowboys and a youngster herd horses in the Panhandle around 1885. Lawmen often had ridden as cowboys before moving into law enforcement. The man at center is packing iron.

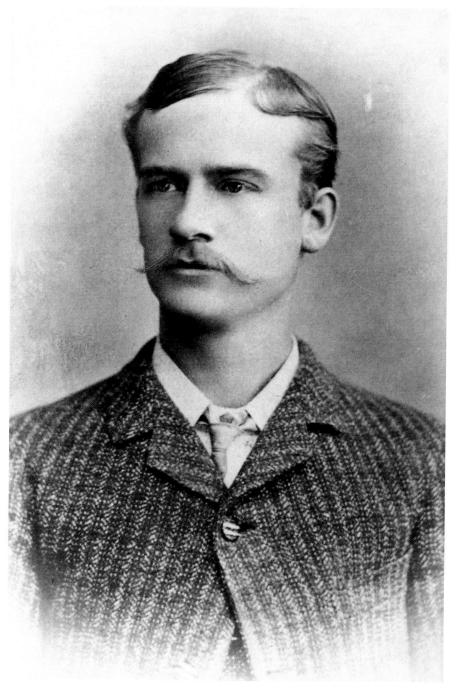

Edward H. Scotten served ably as assistant marshal for El Paso in 1882, but his life was cut short in Hunniwell, Kansas, when he was mortally wounded by a drunken cowboy on August 13, 1884. Scotten died 20 days later.

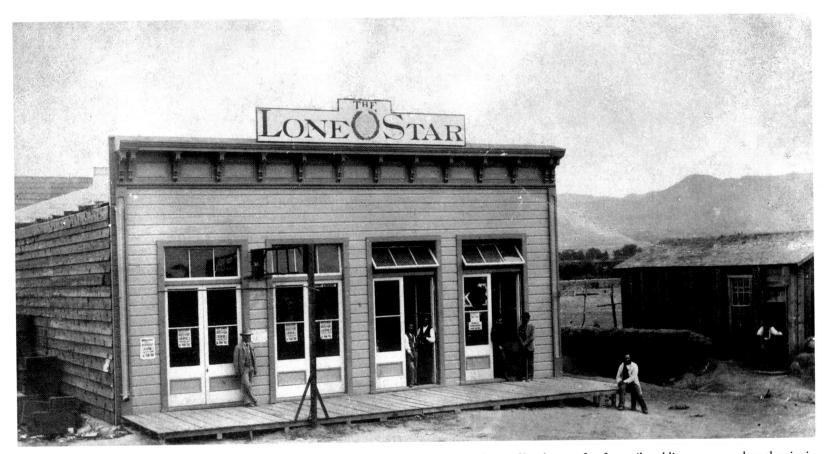

Newspapers in El Paso had no trouble coming up with plenty of local copy after four railroad lines converged on the city in 1881. Murder and mayhem did not occur every day, though at times it seemed it did. Standing at left in front of the offices of the Lone Star is Marshal James B. Gillett, who helped make some of the news. Two printers occupy the third door from the left, while Charles Shannon and newspaper owner S. H. Newman are in front of the door on the right.

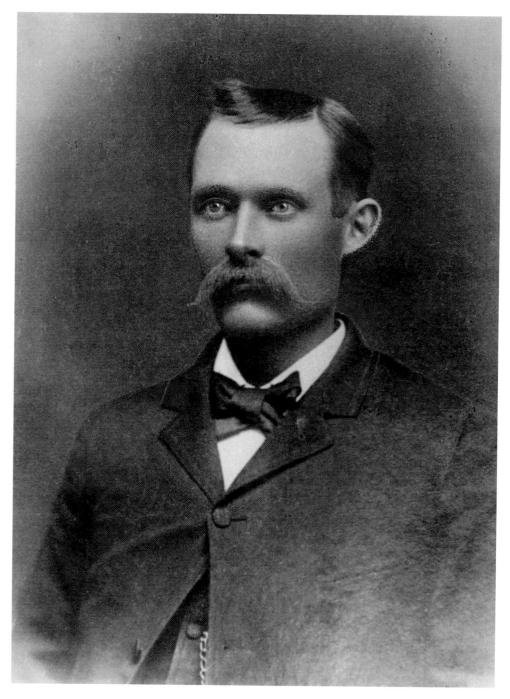

Not all Texas sheriffs looked like the stereotypical western lawman. Shown here in suit and bow tie is Menard County sheriff R. R. (Dick) Russell. First elected November 2, 1886, he served in office for a decade, bringing stability to a frontier county.

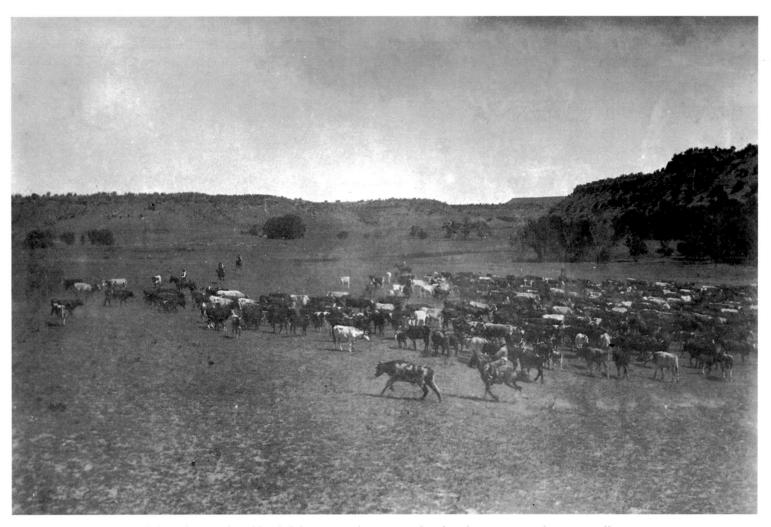

In the fall, cattlemen rounded up their stock and herded them to market. But rustlers found it easier to make money off someone else's beef. Catching cattle thieves and recovering stolen livestock kept nineteenth-century county lawmen and rangers busy. This herd was photographed somewhere in the Panhandle around 1885.

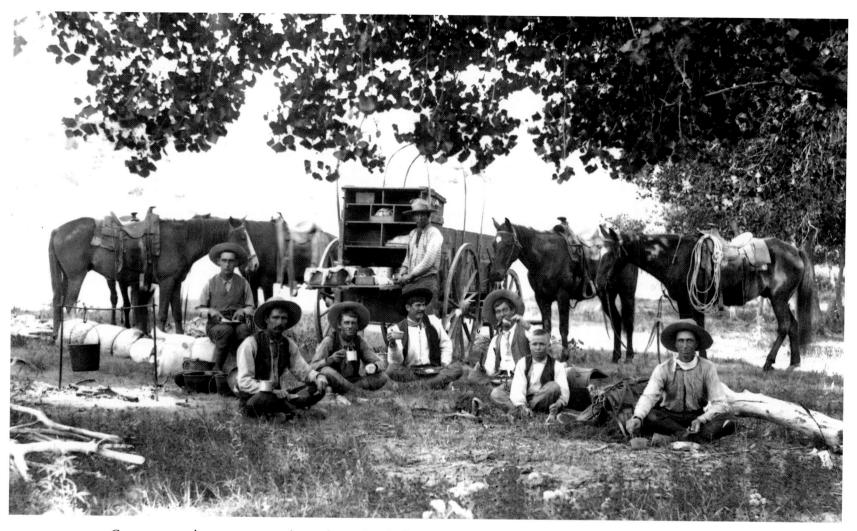

Contrary to myth, not every cowpoke toted a revolver. In fact, it was against the law for anyone but law enforcement officers to go around wearing a gun. Even so, cowboys could get rowdy, especially when they drank anything stronger than the coffee they are sipping in this photograph taken in the Panhandle in the mid-1880s.

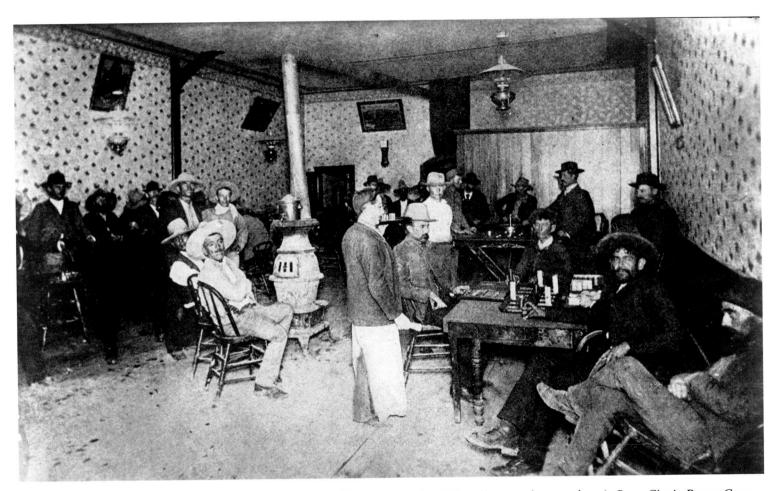

Gambling ran wide open in most Texas towns in the 1880s. This scene shows a saloon in Pecos City in Reeves County. The stern-looking man with the goatee, wearing white, is lawman and future outlaw Jim Miller. His luck later ran out at the end of a lynch mob's rope.

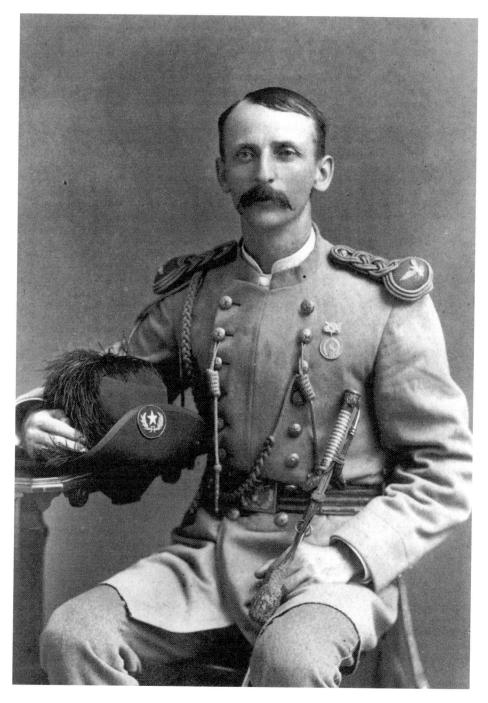

Lamartine P. Sieker, one of four brothers who rode as Rangers, served for a total of 26 years. "Lam" joined in 1874 and eventually rose to the rank of captain. Later promoted to Ranger quartermaster, he worked out of headquarters at Austin. This portrait was made in Austin in 1884 by photographer H. R. Marks. Also in the state militia, Lam wore his dress uniform for this shot.

A typical Texas cowboy of the 1880s poses astride his pony in San Antonio. Any visiting cowpoke that ran afoul of one of Marshal Phil Shardein's gray-uniformed policemen would get to cool his heels in the city jail, locally known as the "Bat Cave." Shardein served as city marshal from January 13, 1879, to February 22, 1893.

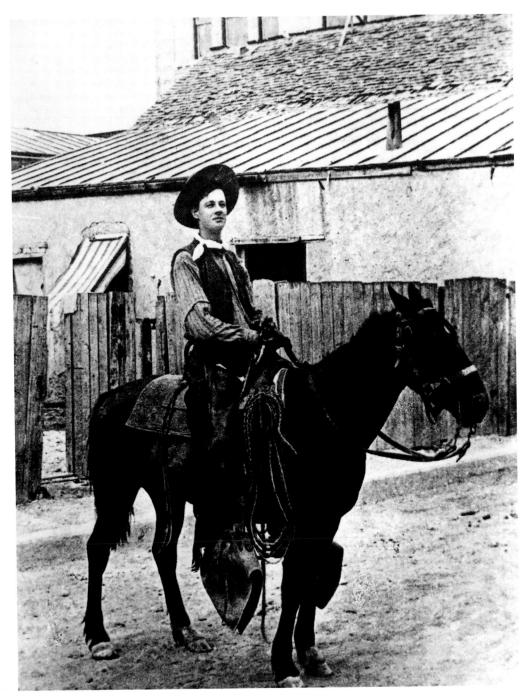

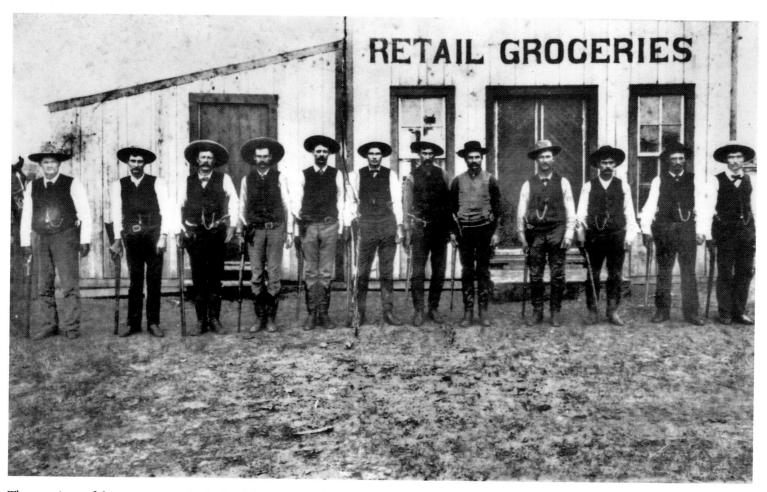

The proprietor of this grocery store in the South Texas town of Cotulla did not have to worry about any sticky-fingered customers the day this photograph was taken, February 16, 1887. Standing in front of the store are a dozen Texas Rangers, each holding a Winchester rifle.

"Longhair" Jim Courtright became city marshal of Fort Worth in 1876 and served for three years. Despite his nickname, in this image Marshal Courtright is reasonably well-shorn beneath a jauntily cocked Stetson, wearing his star-shaped badge on his lapel. Eight years after his tenure as Cowtown's top lawman, Courtright died in a gunfight with gambler Luke Short on February 8, 1887.

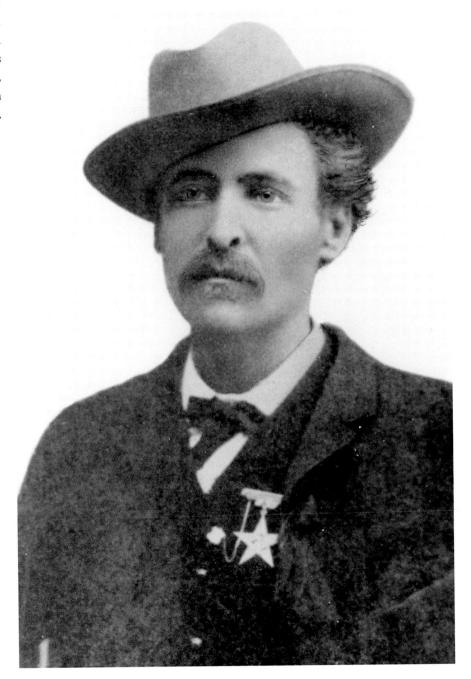

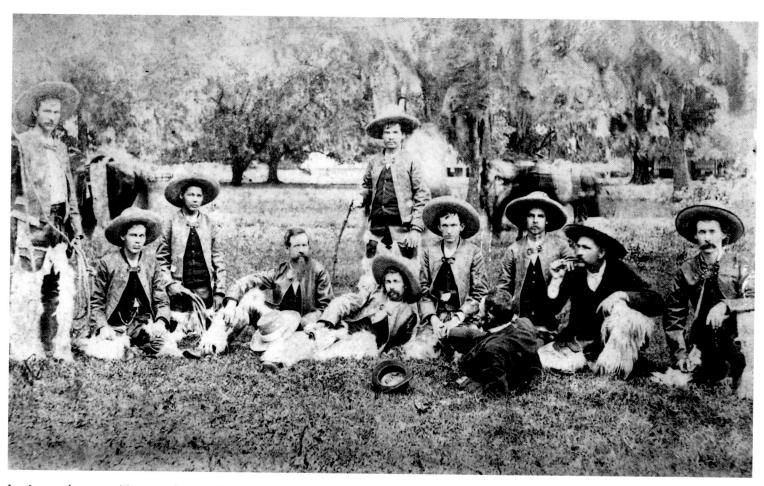

In nineteenth-century Texas, cowboys and lawmen looked alike with one difference: Lawmen carried guns.

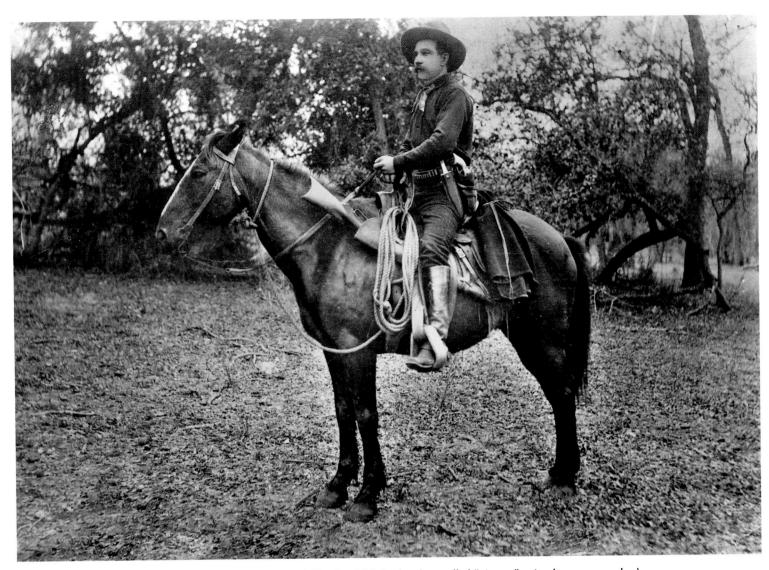

Texas Ranger Ira Aten in 1887. During the Fence Cutters' War, in which lawbreakers called "nippers" ruined many a rancher's barbed-wire fence in protest of the loss of free grass, Aten proposed a novel solution: Rig selected fences with "dynamite bombs." Fortunately for the fence cutters, that proposal never ignited interest. Aten later served as sheriff of Fort Bend County, from August 21, 1889, to November 4, 1890.

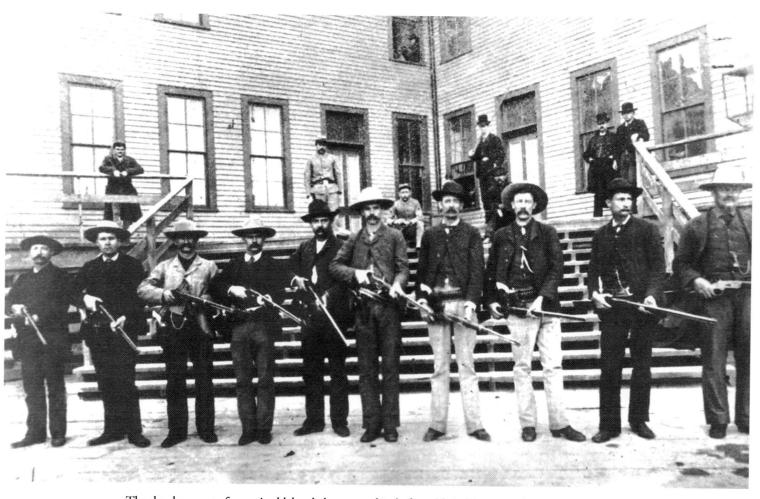

The development of organized labor led to a new kind of trouble in Texas—strikes. When a railroad worker walkout in 1886 triggered violence in Fort Worth, the governor sent in Texas Rangers and militiamen to settle things down. In the foreground here are the men of Captain George H. Schmitt's company. From the left are Will Owens, Henry Putts, J. C. Barringer, Sam Pickett, Charles Kuhley, G. H. Clark, J. R. Robinson, Corporal J. W. Durbin, Lieutenant A. C. Grimes, and Schmitt.

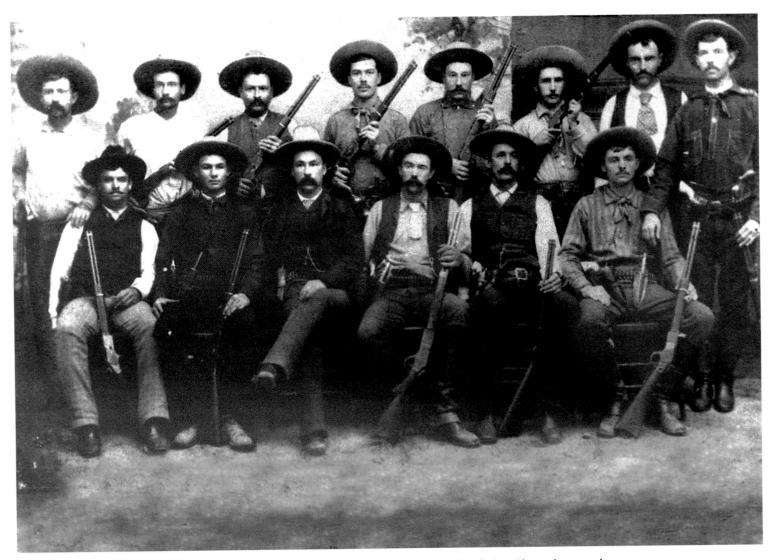

Contrary to the Hollywood image, most rangers did not crease their hat crown or bend their brims. Shown here are the boys of Company D, taking time for a group photograph while working in South Texas around the town of Realitos in present Duval County.

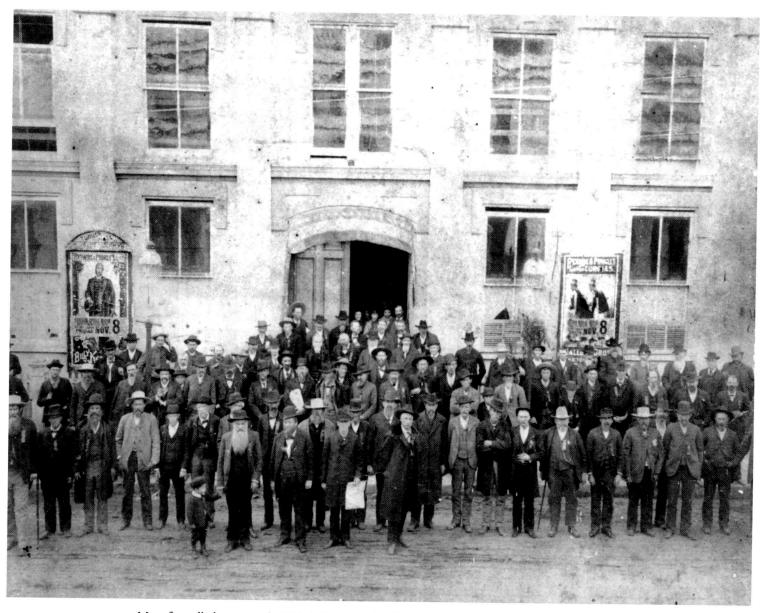

More formally known as the Eighth Texas Cavalry, Terry's Texas Rangers fought valiantly in the Civil War. Though soldiers, many of the men had ridden as Texas Rangers before the war and some served in that capacity after the conflict. These veterans met for a reunion in San Antonio in 1889.

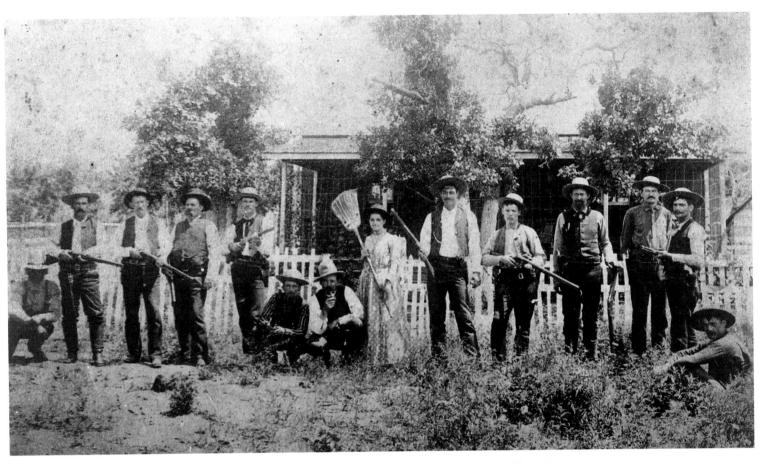

Rangers could be tough on lawbreakers, but many of the state lawmen had a robust sense of humor. When Captain Sam McMurry's company posed for this photograph at the coal-mining town of Thurber in 1889, the wife of Sergeant Sam Platt (smoking the pipe) armed herself with a broom.

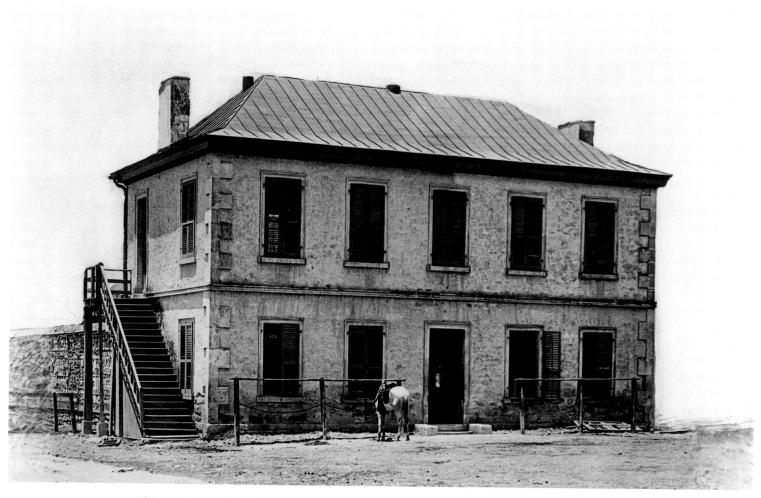

This sturdy stone building served as the Bexar County Jail in San Antonio until 1879 when the city took it over as its police headquarters, municipal jail, and "recorder's court" (an early term for a municipal court handling misdemeanor cases). The city continued to use the building until 1890.

From the opposite direction, this is another view of the old San Antonio lockup, not-so-affectionately known by both inmates and cops as the Bat Cave.

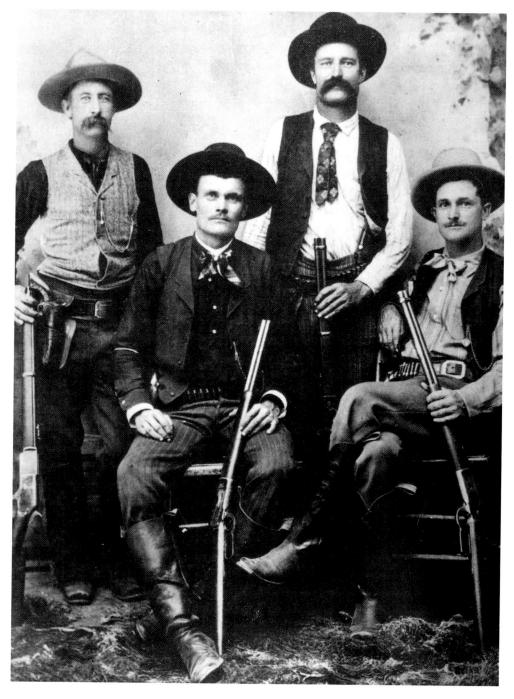

Compared with other states, Texas never had much mining activity. But for a time, the Big Bend town of Shafter prospered near a flourishing silver mine. Shafter's remoteness and boom town status often led to disorder that the Rangers had to handle. Standing, from the left, are rangers Bob Speaker and Jim Putnam. Seated, from the left, are ranger Lon Oden and Captain John R. Hughes.

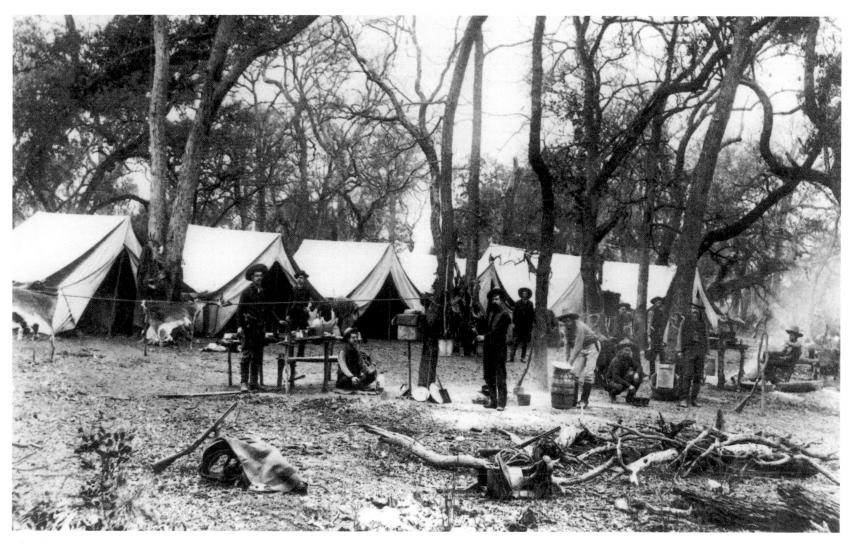

Though Ranger Captain John R. Hughes spent much of his long career working out of Ysleta in El Paso County, Rangers were dispatched where needed. In this photograph, rangers under Hughes are camped along the Leona River in Uvalde County in South Texas.

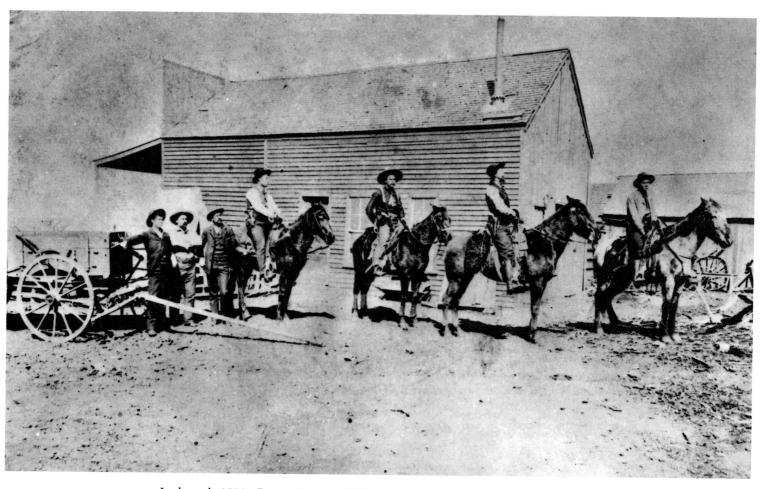

In the early 1890s, Ranger Captain William J. McDonald and his company were stationed in the new railroad town of Amarillo until local officers got it stabilized.

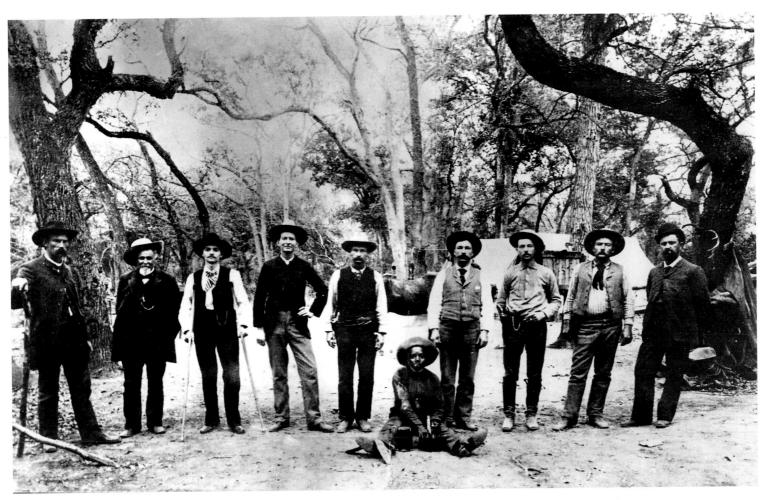

A group of Rangers in South Texas and their cook, who is sitting. Not all the men in this photograph are identified, but the fifth and sixth from the left are Bazz Outlaw, who after he left the Rangers would be killed after killing a ranger in El Paso, and Captain Frank Jones, who also did not get to live to old age.

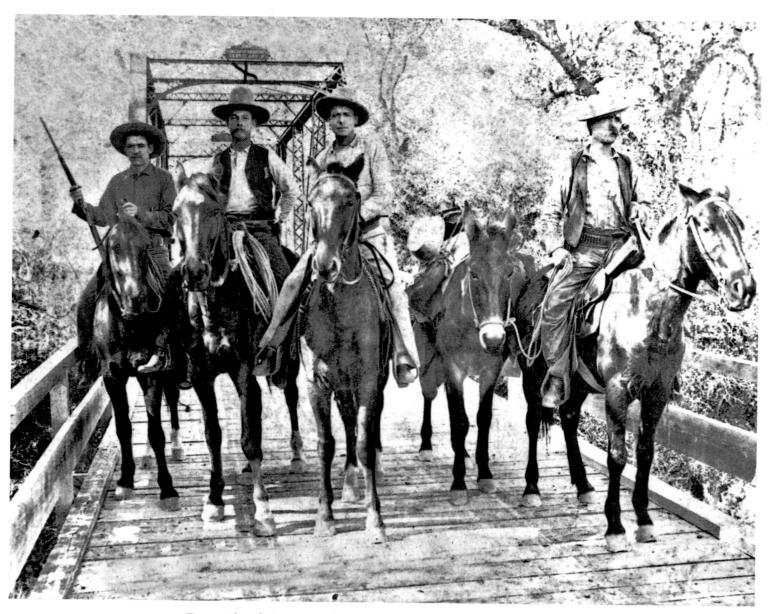

Four unidentified rangers and their pack mule cross an iron and wood bridge as they head out on a scout in 1892.

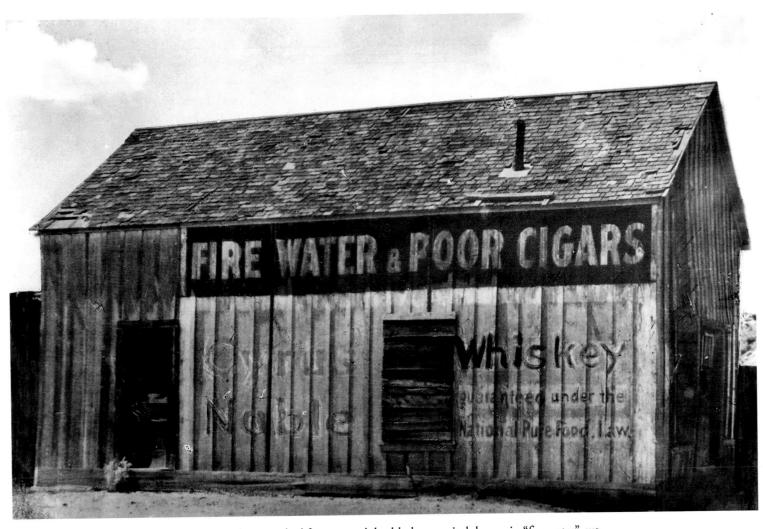

No one had yet scientifically proven that smoking was bad for a person's health, but overindulgence in "fire water" cut short many a life in early day Texas. Many lawmen, like others, drank too much.

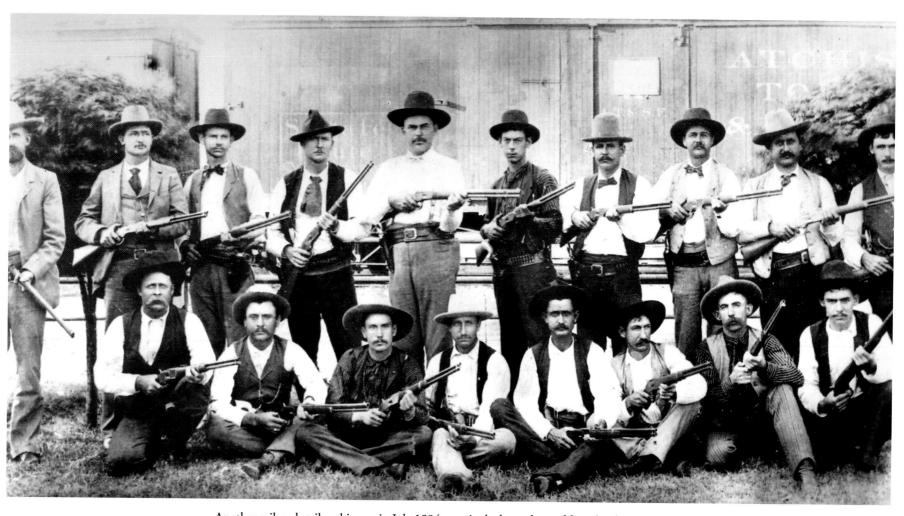

Another railroad strike, this one in July 1894, required a large show of force by the Rangers to keep the labor dispute relatively peaceful.

When Val Verde County was organized in 1885, Roy Bean of Langtry (1825–1904) got elected justice of the peace. He could only adjudicate misdemeanor cases, but his penchant for strong drink and hijinks coupled with a fondness for publicity combined to make him one of the most storied characters of the Old West—the Law West of the Pecos. Rangers and other lawmen turned to him to file their criminal cases and act as coroner.

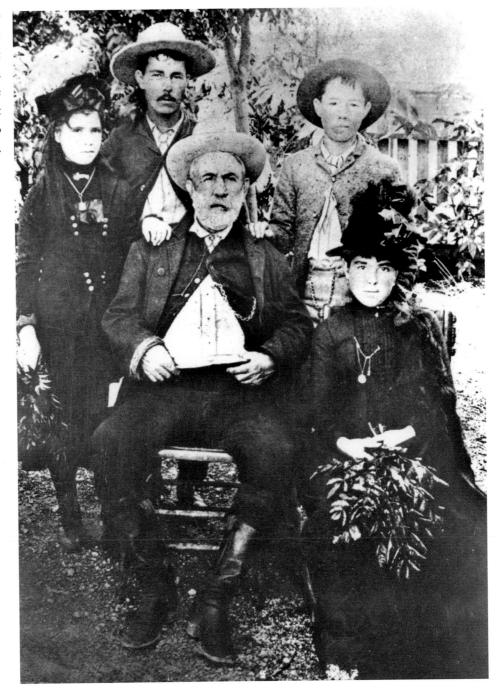

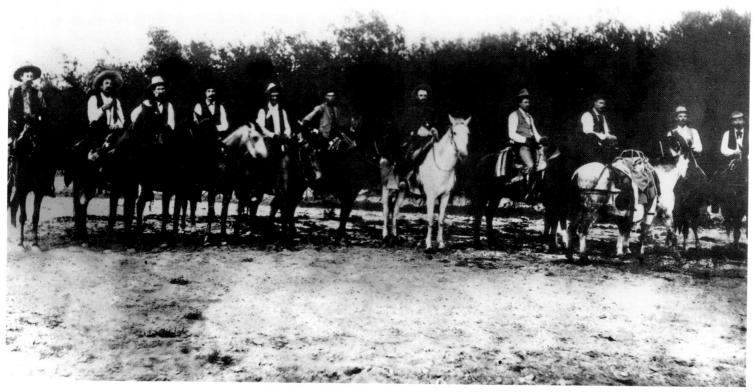

Rangers often worked with the U.S. Marshal's Service, especially when looking for fugitives. Shown here in this 1894 image taken on a rare rainy day at Ysleta are rangers under Captain John R. Hughes (eighth from left) and deputy U.S. Marshal F. W. McMahon, a former ranger.

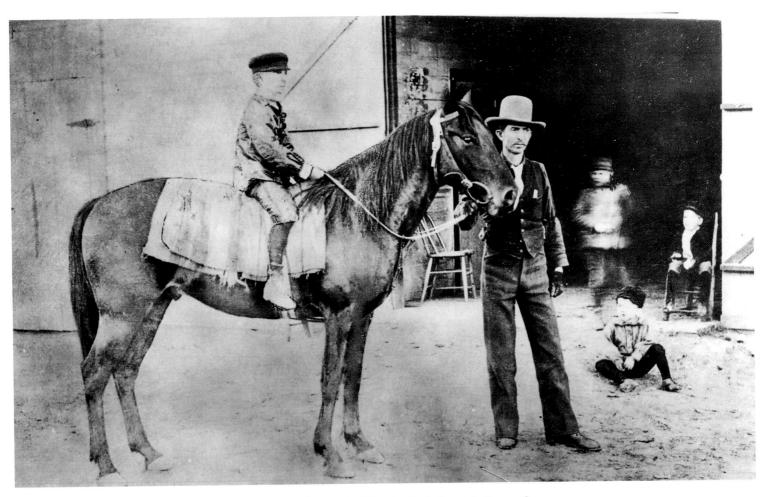

Emmanuel "Mannie" Clements, Jr., served for a time as a deputy sheriff under G. A. Frazer in Reeves County. Shown here in the county seat of Pecos City in 1894, he's holding a horse with young Len Driver astride it as other kids look on. Clements' father, a cousin of outlaw John Wesley Hardin, died in a shoot-out in a Ballinger saloon in 1887 during a heated campaign for Runnels County sheriff.

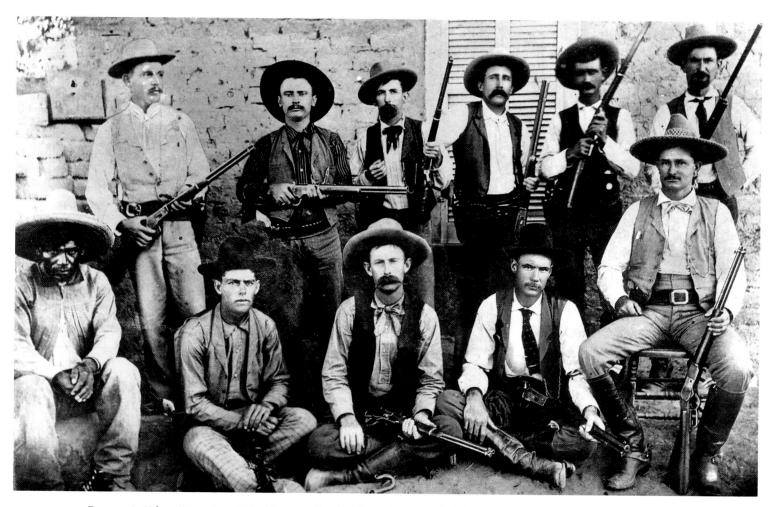

Rangers in Ysleta, Texas, in 1894 with one sullen-looking prisoner (at far left). Captain John R. Hughes, seated at far right, supposedly gave ranger George Tucker (in black hat next to the prisoner) a thorough chewing out over being so careless with his six-shooter, which the man in custody could easily have grabbed. Standing, from left, are U.S. Marshal F. M. McMahon, William Schmidt, James V. Latham, Joe Sitter, Ed Palmer, and Thalis T. Cook. Sitting are the prisoner, Tucker, J. W. Saunders, Sergeant Carl Kirchner, and the captain.

In the early days, few men made a lifelong career of law enforcement. J. H. McMahan of Del Rio, shown here, rode with the Rangers for a time, but found he could make more money doing other things. He spent most of the rest of his life trapping along the Rio Grande, taking more beaver pelts along the river than anyone else known.

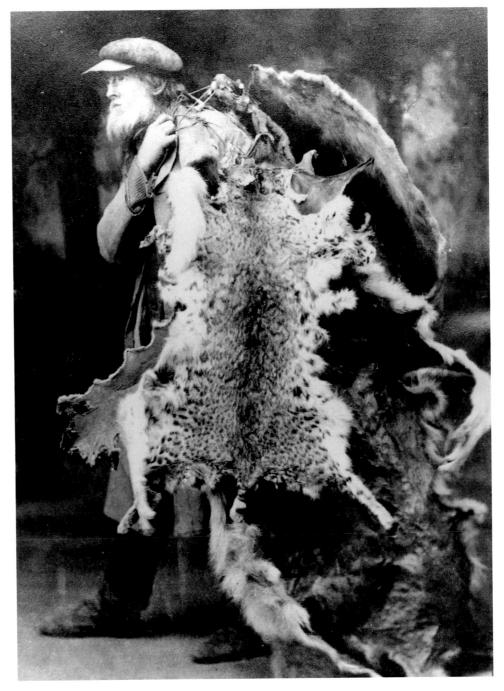

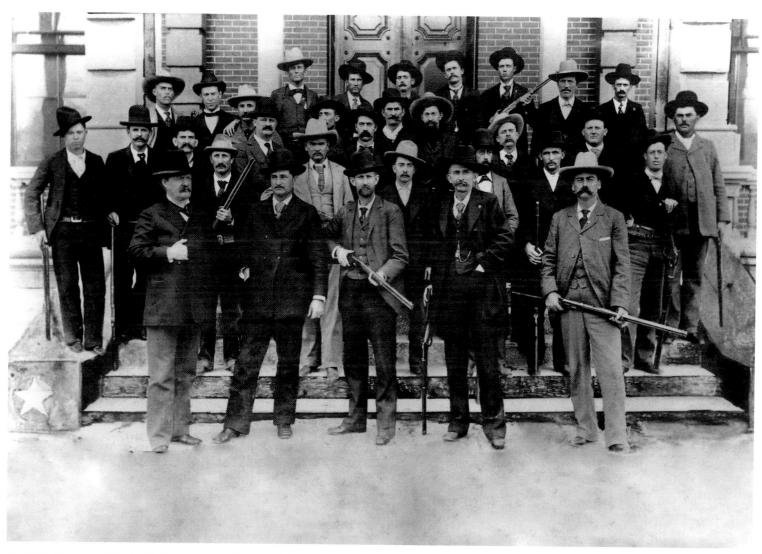

In 1896, Governor Charles Culberson ordered most of the Ranger force to El Paso to prevent a scheduled and much ballyhooed prizefight between Peter Maher and Robert Fitzsimmons. The lawmen succeeded in keeping the match from coming off in Texas, but could not stop the promoters from staging it on an island in the middle of the Rio Grande near Langtry.

Former ranger A. J. Sowell (at upper-left) later in his life. In the 1880s and through the 1890s, Sowell made another contribution to Texas history by interviewing old-timers and publishing their recollections in books and newspaper articles. Also shown are family members, clockwise beginning second from left, John Sowell, Paleman S. Sowell, Leroy Sowell, and James A. Sowell.

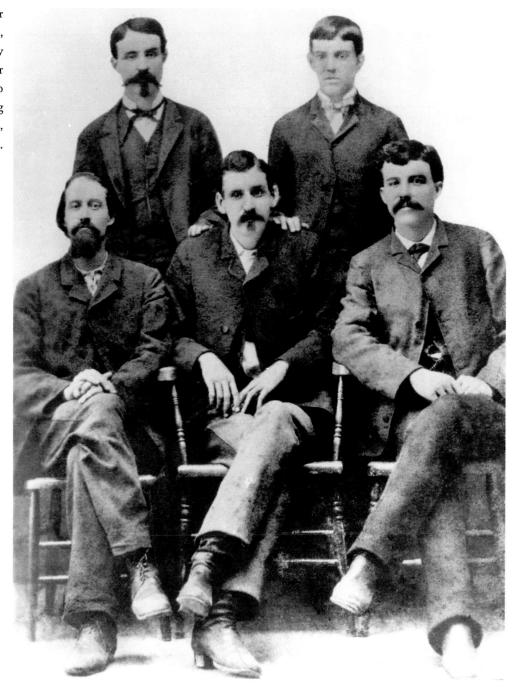

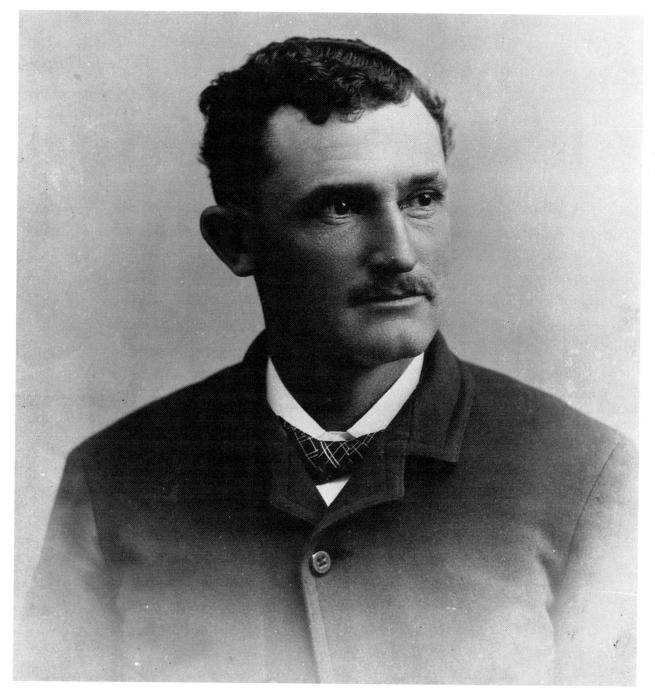

John R. Hughes, earlier in his Ranger service, sat for this photograph on Main Plaza in San Antonio in the 1890s. The Illinois-born Hughes first joined the Rangers in 1887 at Georgetown, leaving behind life as a rancher in favor of a long career as a state lawman.

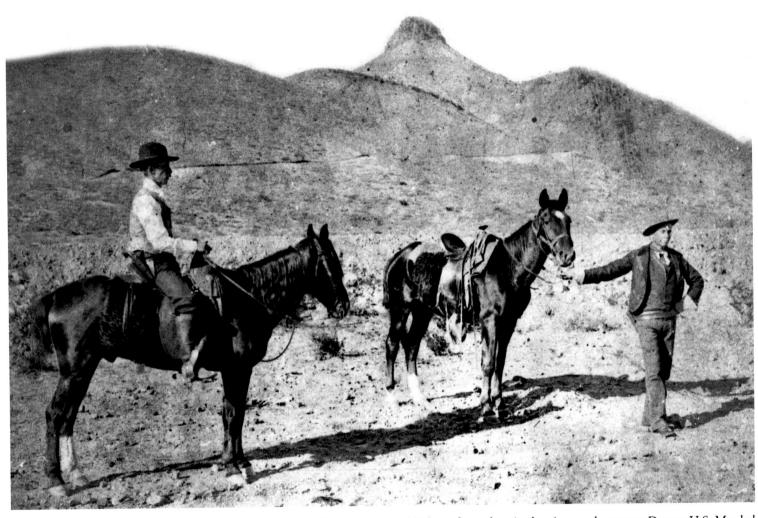

The rugged vastness of far west Texas made a good hideout for outlaws in the nineteenth century. Deputy U.S. Marshal A. B. Cline and a customs inspector named Green (standing with his horse) pose for a photographer somewhere in the Trans-Pecos in the 1890s.

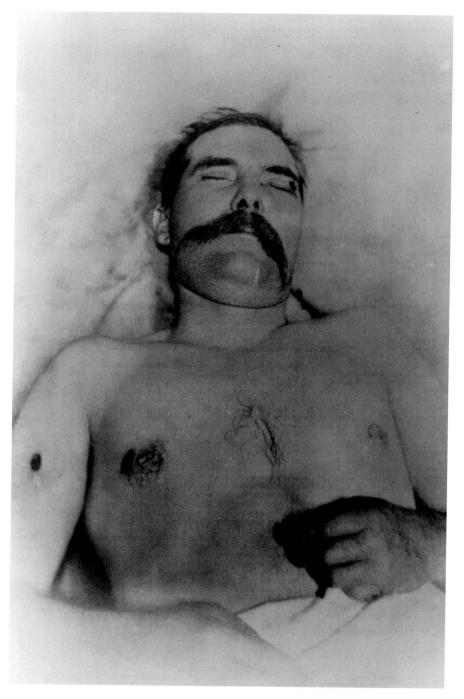

The end of the line for Texas' deadliest nineteenth-century outlaw, John Wesley Hardin. Released from prison less than two years earlier, Hardin was shot to death in El Paso's Acme Saloon by Constable John Selman. Drunk and shooting dice at the time, Hardin's reputed last words were "four sixes to beat!"

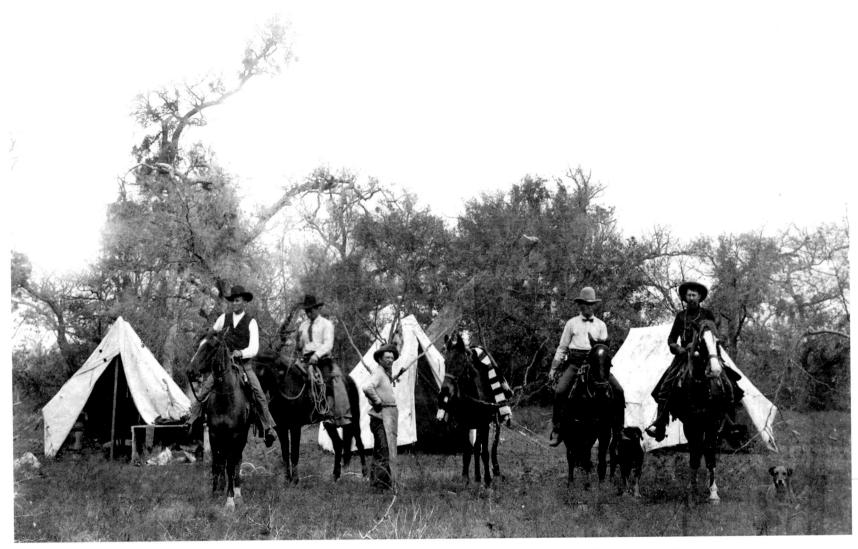

In 1896, Company B Rangers rode to San Saba County to deal with a wave of vigilantism laid to a group called the "San Saba Mob." Left to right are Edgar T. Neal, Allen R. Maddox, Tom Johnson (camp cook), Dudley S. Barker, and John L. Sullivan.

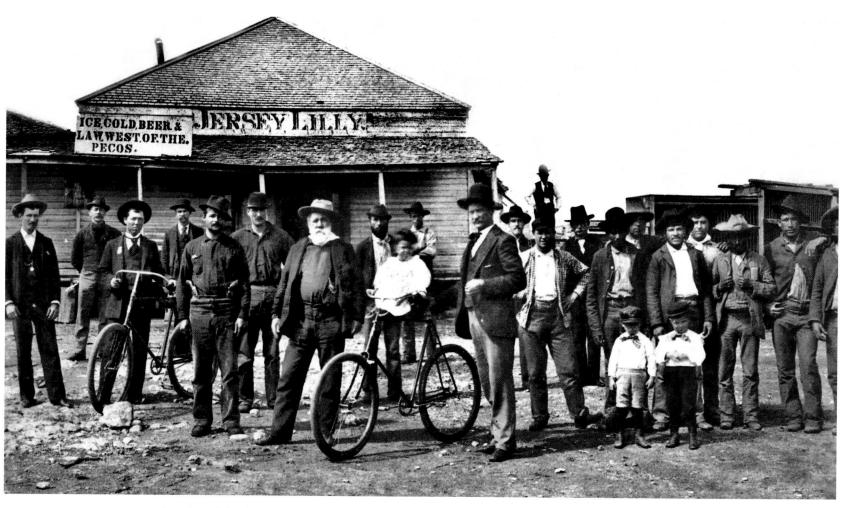

In a sign of the changing times, a white-bearded Judge Roy Bean stands outside his famed Jersey Lilly Saloon in Langtry flanked by two newfangled bicycles. This image was recorded sometime prior to 1897.

Storied Texas Ranger William Alexander Anderson "Big Foot"
Wallace survived imprisonment in Mexico and numerous
Indian fights to make it to old age. He liked to attend oldtimers reunions and in this image wears a ribbon from one such
event. Wallace died in Frio County on January 7, 1899.

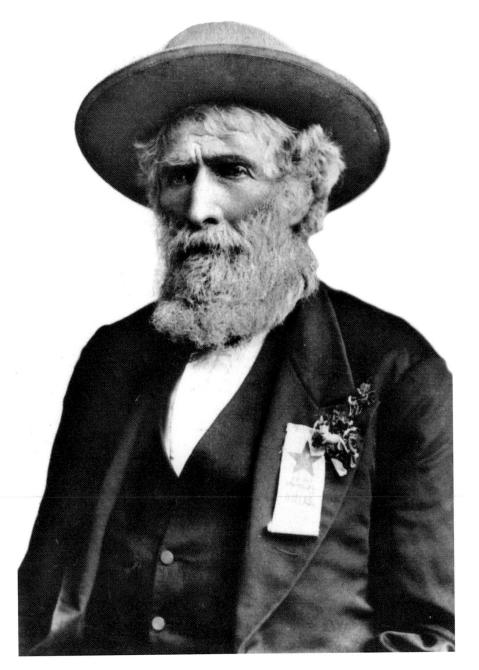

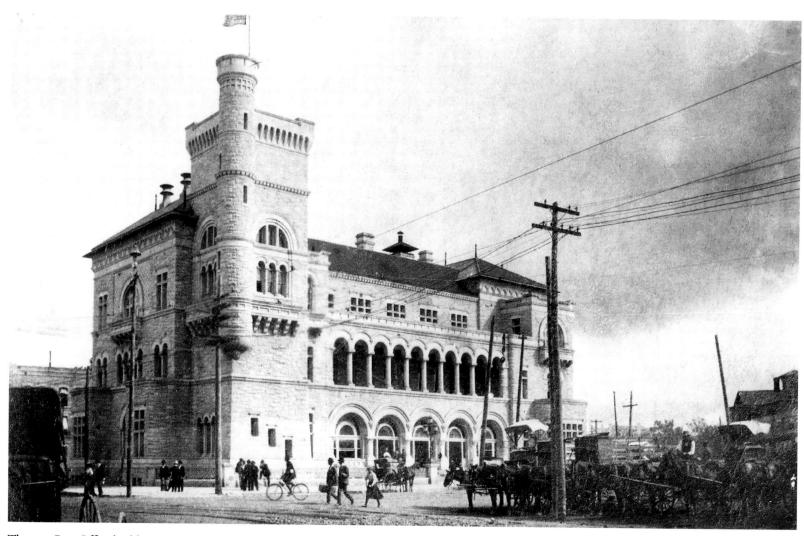

The new Post Office building in San Antonio also housed the U.S. Marshal for the Western District of Texas when it opened in 1898.

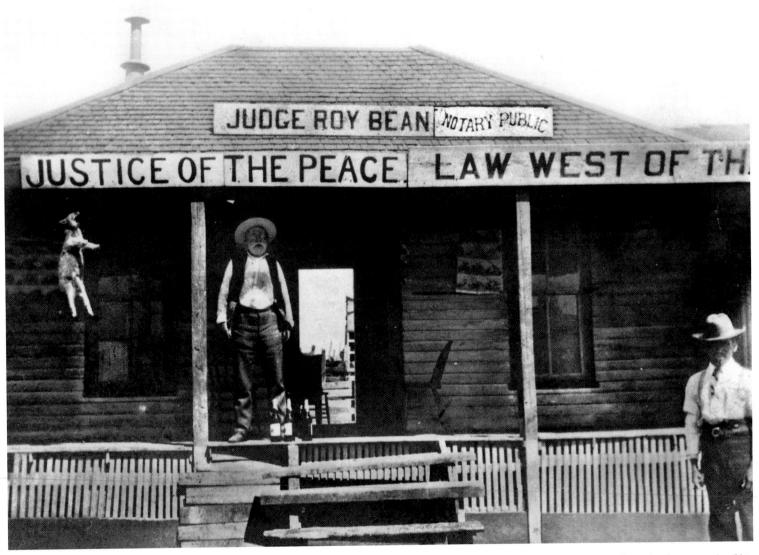

No matter legend, Judge Roy Bean never had anyone hanged. But someone did string up a dead animal on the front porch of his saloon and office, a necessary step in the preparation of the border delicacy of *cabrito*—baked goat.

CHAPTER THREE

(1900-1919)

Judge Roy Bean, cane in one hand, cigar in the other. Beyond a good smoke, he longed for British actress Lillie Langtry, the "Jersey Lilly." Alas, the crusty judge never got to meet her in person, though once after his death her train did stop briefly in Langtry. The town was named for railroad engineer George Langtry, not Lillie, but Bean had dubbed his saloon the Jersey Lilly in her honor.

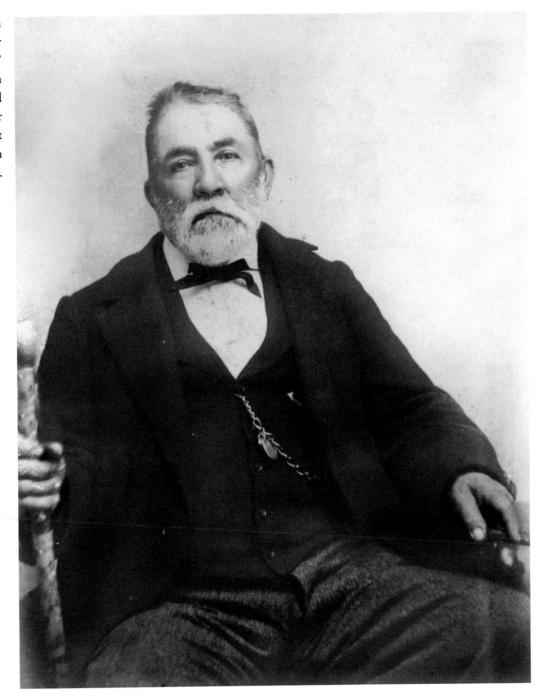

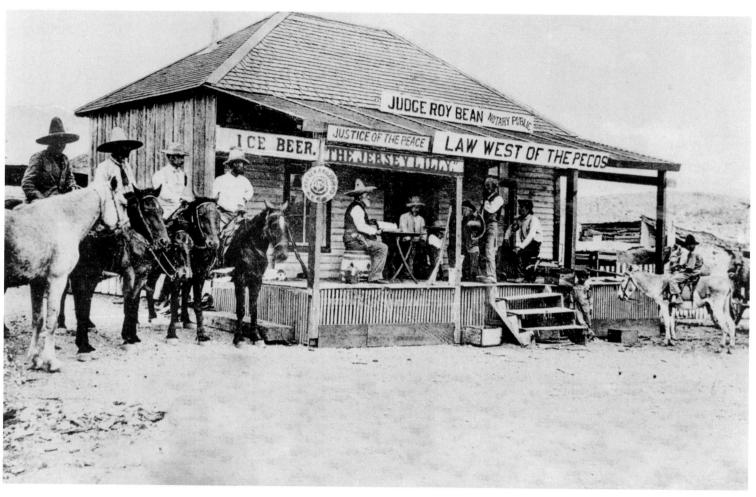

The weather being too hot to convene court inside, Judge Roy Bean presides over a hearing on the porch of his office-saloon at Langtry. This photograph was taken about 1900, four years before his death. He was buried in Del Rio.

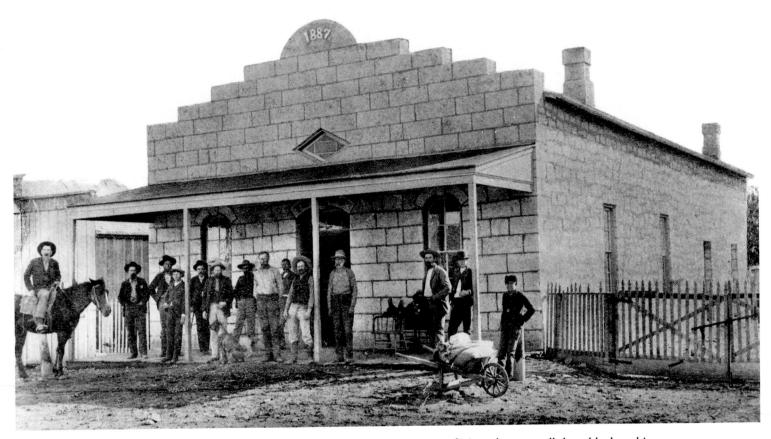

With a facade reminiscent of the Alamo, the Old Rock Saloon in the West Texas town of Menard was not all that old when this photograph was taken in 1901. The watering hole was built in 1887. All the men standing in front of the saloon appear to be abiding by the law and not carrying a pistol.

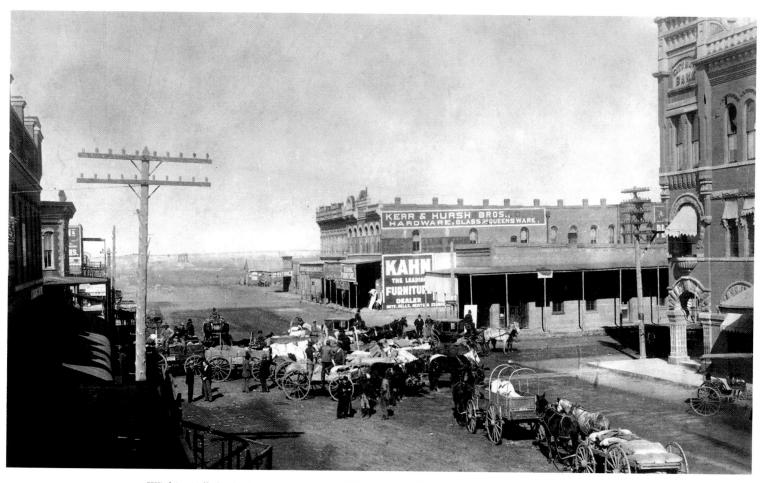

Wichita Falls had telephone service in 1900, but people and goods still moved on horses or wagons. So did local lawmen.

These 21 wagons are loaded with wheat from Archer and Young counties.

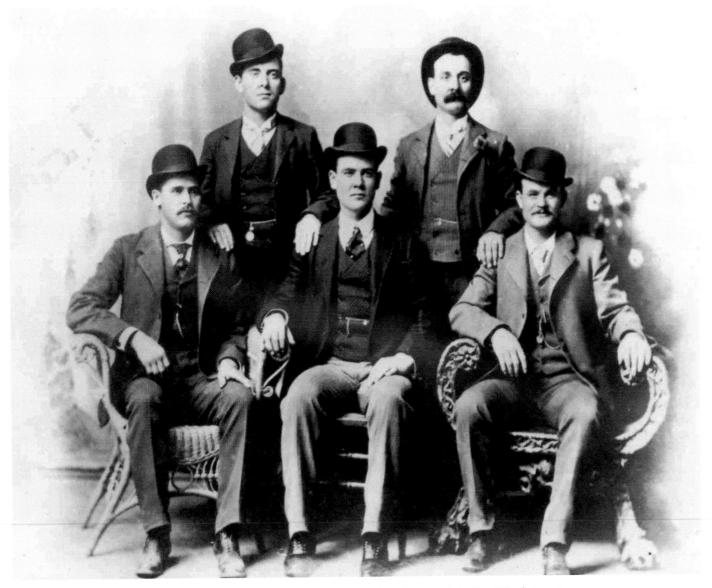

The Hole in the Wall Gang, better known as the Wild Bunch, posed for this photograph in Fort Worth in December 1900. From left to right are Harry Longabaugh (the Sundance Kid), Will Carver, Ben Kilpatrick, Harvey Logan (Kid Curry), and Robert Leroy Parker (Butch Cassidy). Though the gang did most of its robbing outside Texas, Carver and Kilpatrick had Texas roots.

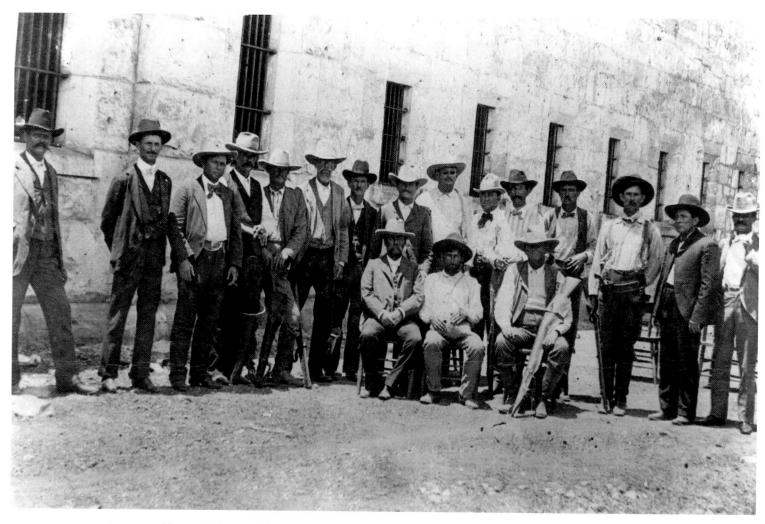

A suspected horse thief named Gregorio Cortez killed Karnes County sheriff W. T. "Brack" Morris June 12, 1901. Three days later Cortez killed another lawman, Gonzales County sheriff Robert M. Glover. Lawmen trailed Cortez all across South Texas before Ranger Captain J. H. Rogers finally captured him without a shot. In San Antonio, participants in the horseback pursuit posed with the prisoner (seated between two officers) in front of the Bexar County Jail.

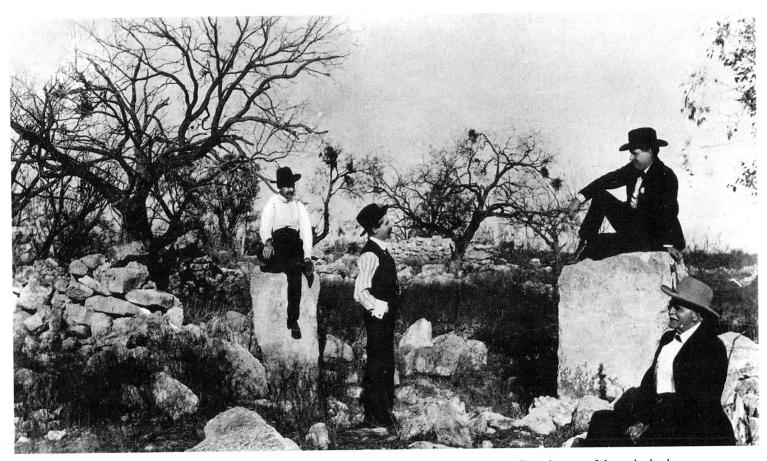

Marvin Hunter (standing), longtime newspaper publisher and founder of *Frontier Times* magazine, collected many of the early day law enforcement photographs that appear in this book, in collaboration with his friend Noah H. Rose. He is shown here in 1903 visiting with three friends at the ruins of an old Spanish mission near Menard, one of the towns where Hunter once published a newspaper.

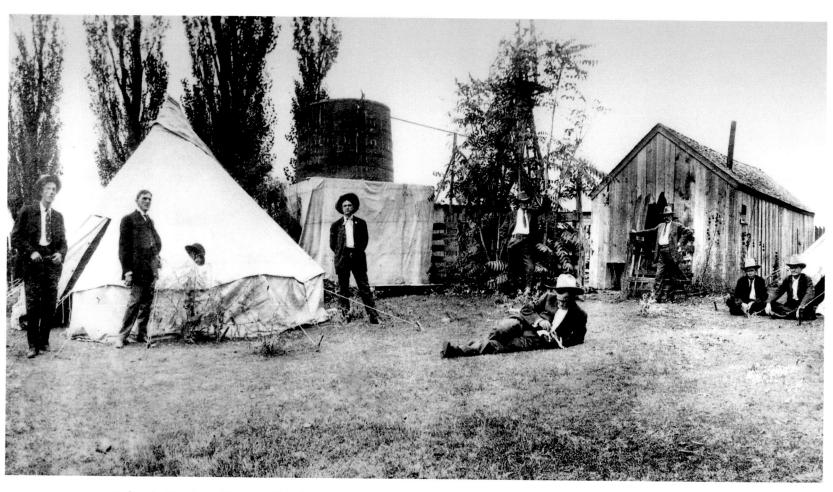

Colorado City (in earlier years, "City" was frequently dropped from its name) lay astride the Texas & Pacific Railroad and railroad towns often created business for the Rangers. Shown here in camp at "Colorado, Texas" in 1908 are, from the left, A. R. Baker, a man unidentified, Ivan Murchison, T. S. White, Parker Weston, Captain Frank Johnson, Billie McCauley, and O. J. Rountree.

A pensive-looking Tom Young shortly before William County sheriff Sampson Connell hanged him in front of a large crowd on the outskirts of Georgetown for the brutal murder of his twelveyear-old stepdaughter. The execution took place March 30, 1906.

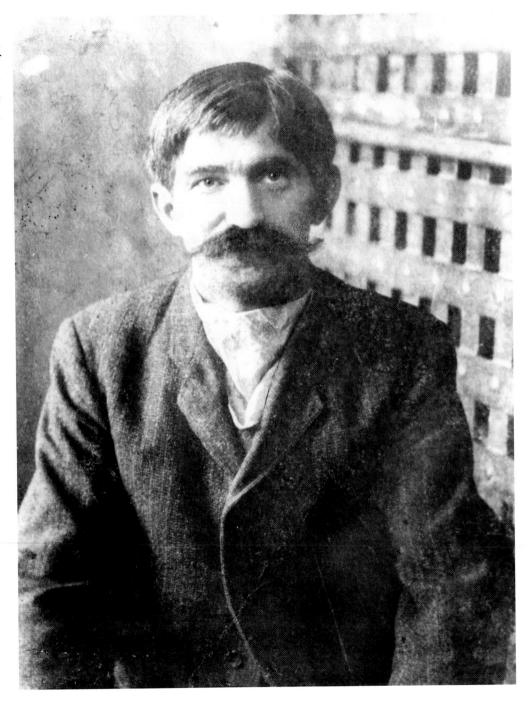

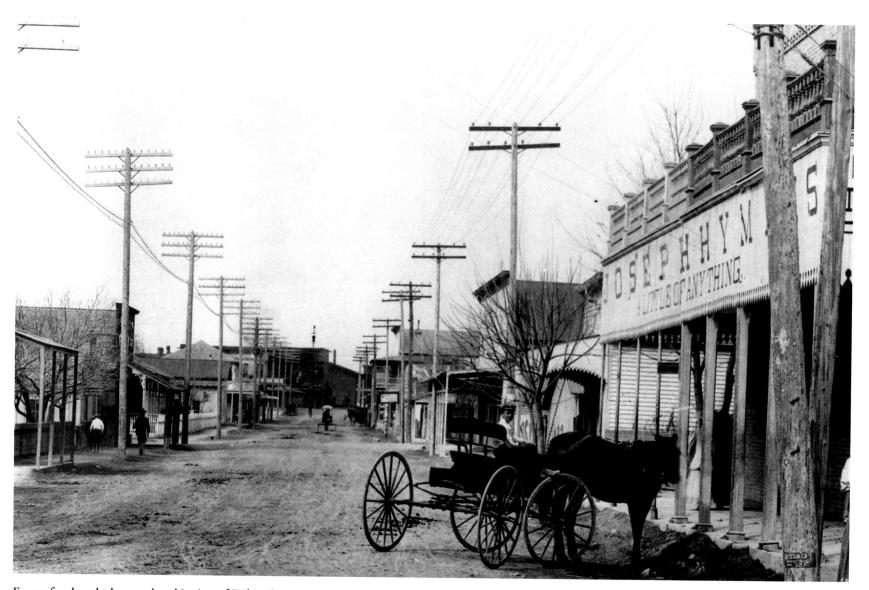

Except for the telephone poles, this view of Del Rio's Main Street in 1906 could have been a Hollywood movie set. Automobiles had begun to enter the market, but all the vehicles in this image are still on one-horse power.

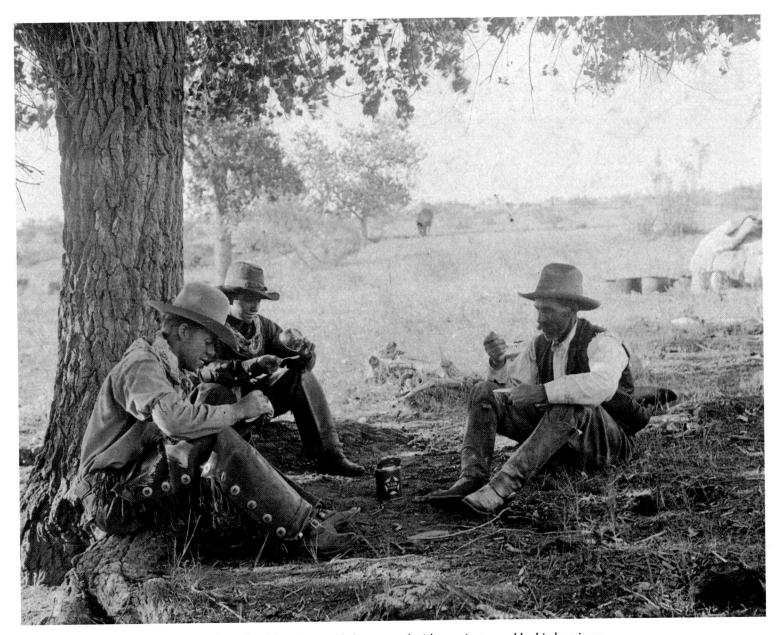

In popular media portrayals, Texas cowboys drank heavily, gambled, consorted with prostitutes, and had itchy trigger fingers. In reality, most were just hard-working boys. These three cowboys are enjoying dinner (old Texas talk for "lunch") under the shade of a rare tree on the sprawling LS Ranch in northwest Texas in 1907.

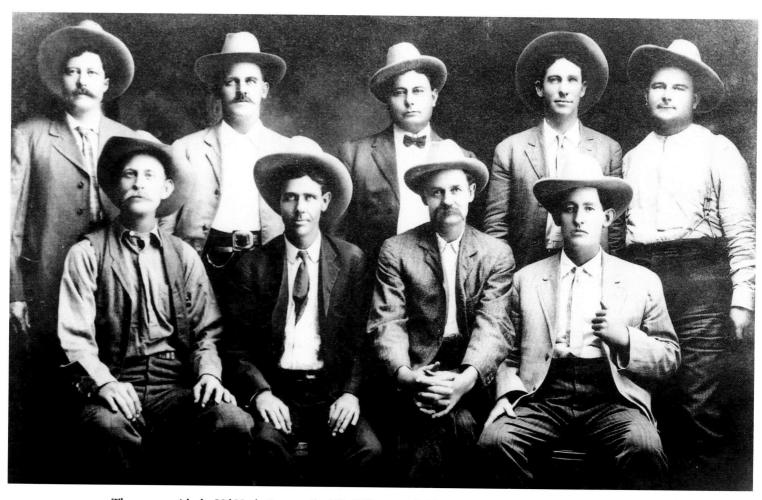

These men with the Val Verde County Sheriff's Office provided law and order for 3,232 square miles of Texas in 1909. From the left, standing are Deputies W. B. Edwards, Mike Sharp, John Wernette, Ross Roberts, and Milam Wright; seated are Fred Jones, Charles Craighead, F. J. Held, and Sheriff C. C. Hartley. He held office for one term, 1908-10.

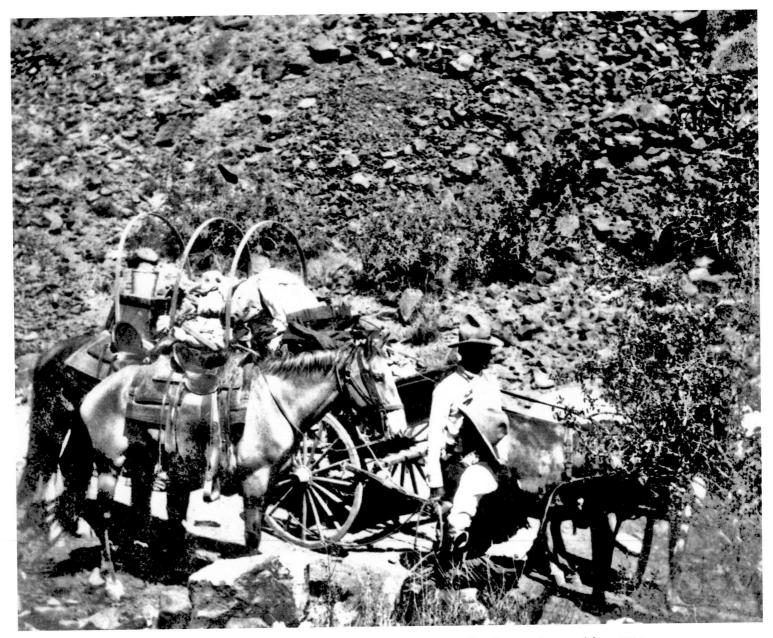

Texas Rangers with a supply wagon in the Big Bend around 1906. Rangers shown are Herff A. Carnes, who served from 1903 to 1911, and Charlie Brown, service time not known.

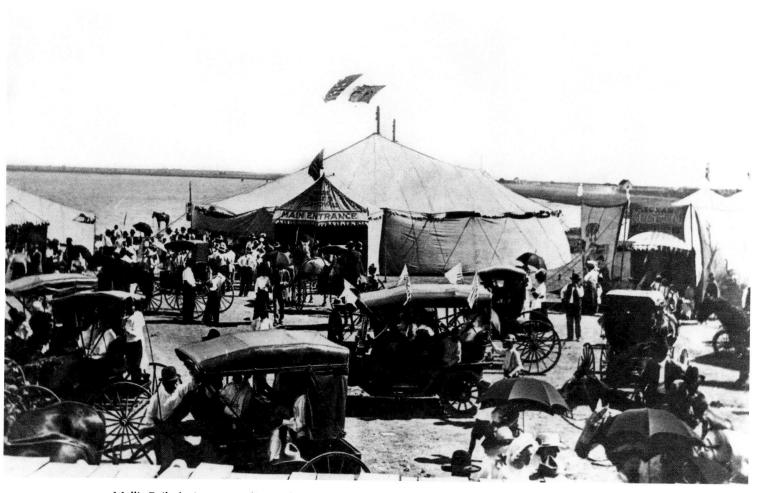

Mollie Bailey's circus toured Texas for more than a quarter of a century, and she did not like it when city marshals showed up to collect an "occupation" tax. To get around the levy, Mollie bought the land on which she pitched her tents, usually donating the property for civic use once she no longer needed it. This image was taken at Lockney on July 4, 1906.

Lee County sheriff James S. Scarborough poses with sixshooter in hand. Scarborough served two terms as sheriff of Lee County and from 1914 to 1923 as sheriff of Kleberg County in South Texas.

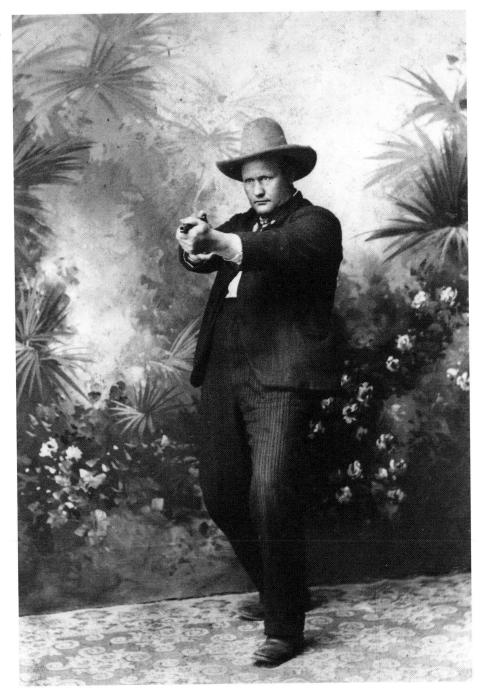

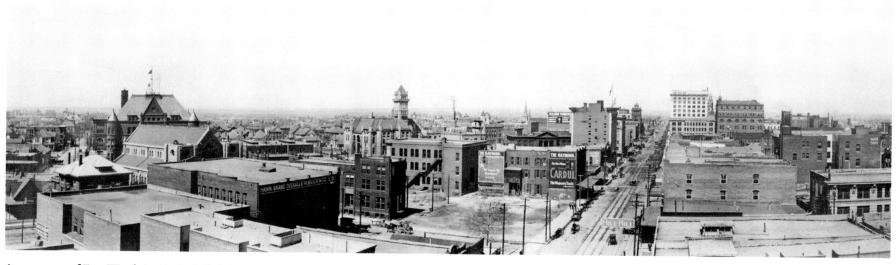

A panorama of Fort Worth in 1910. Called Cowtown about as often as Fort Worth, the city had one of the wildest saloon and red-light districts in the West. Known as Hell's Half Acre, it began in the early 1870s and continued to flourish up to 1919, despite occasional local reform efforts. Killings and other crimes were commonplace in an area of downtown covering far more than half an acre.

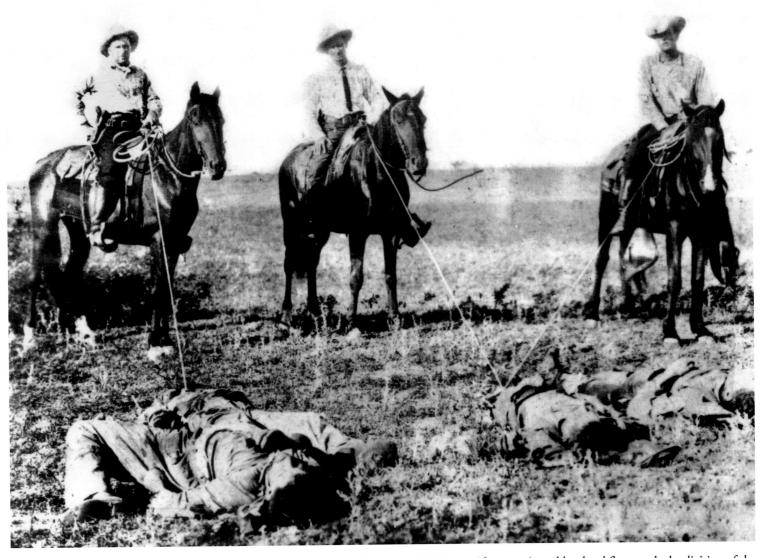

On August 8, 1915, as part of the Plan of San Diego, Mexican raiders carrying a blood-red flag attacked a division of the King Ranch at Norias, a station on the St. Louis, Brownsville and Mexico Railroad. Though rangers did not participate in the successful defense of Norias, they arrived in time to pose for pictures with the bodies of four of the raiders. The staged photo, distributed as a postcard by Brownsville photographer Robert Runyon, created considerable controversy.

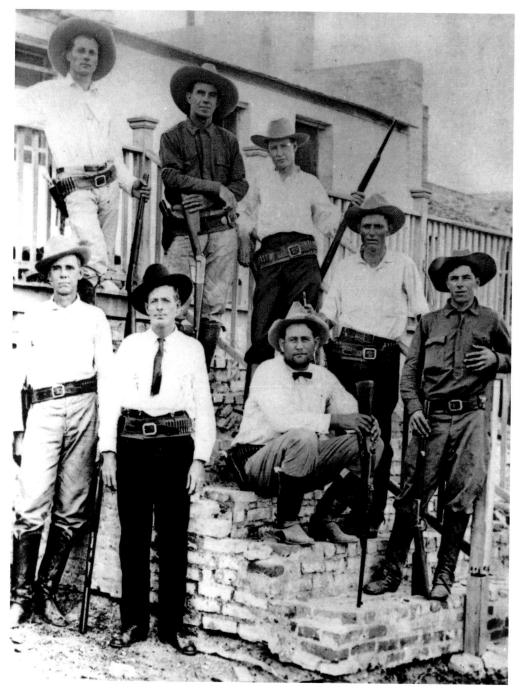

Texas Rangers, federal river guards, U.S. soldiers, county officers, and vigilantes crisscrossed the Rio Grande Valley in 1915 looking for Mexican bandits. Photographed in Rio Grande City are, top left to right: Dunk Wright; Ed Dubose, Sr.; Joe Taylor; Lupe Edwards; and Bennie DuBose. Below, left to right, are R. W. Aldrich, a man unidentified, and J. E. Davenport.

Company D ranger Bert Clinton Veale stands for a photograph in Pharr in 1917. Veale served several enlistments in the Rangers from 1915 to 1919. In this image, he is armed with a Winchester Model 1895 .30-caliber rifle.

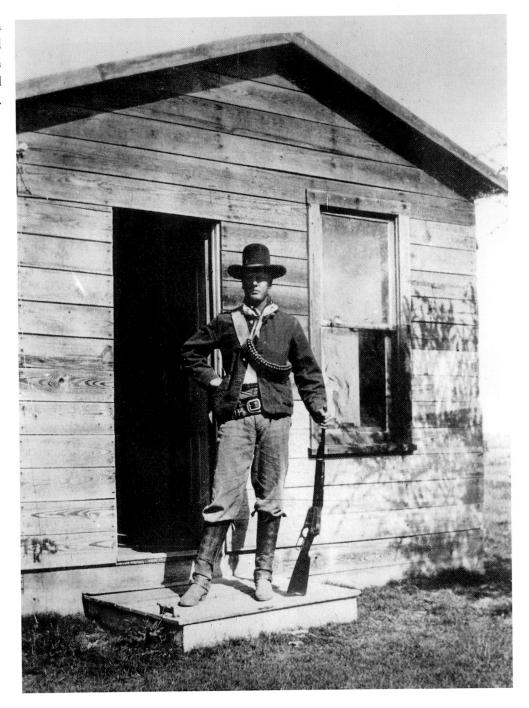

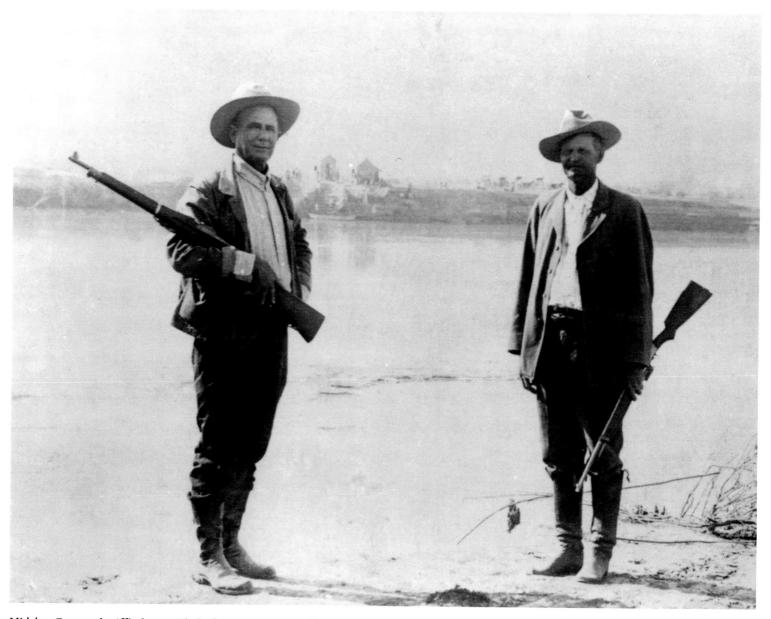

Hidalgo County sheriff's deputy Clark (first name not noted) and Customs Inspector J. D. White stand on the bank of the river separating Texas from Mexico, the storied Rio Grande.

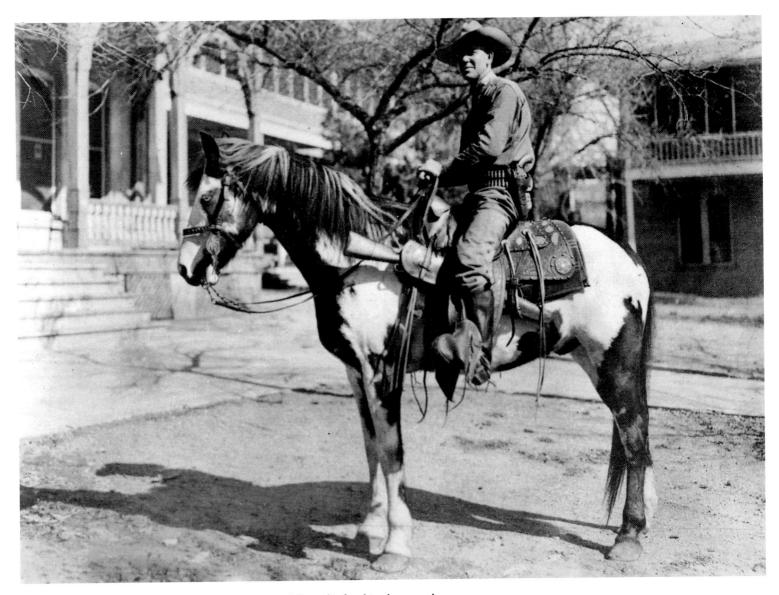

An unidentified Texas Ranger and his mount pose in full regalia for this photograph.

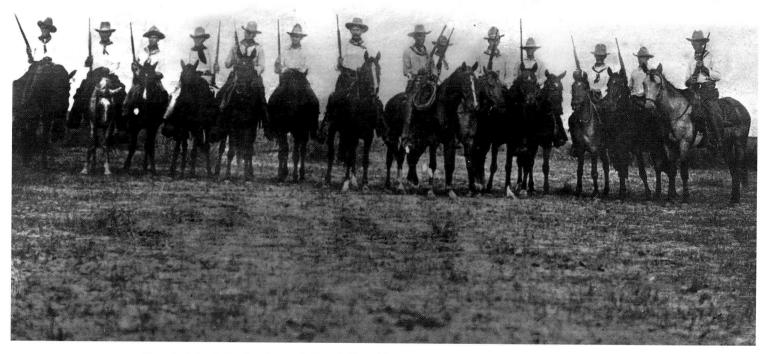

Captain John J. Sanders (seventh from left) and his men of Company A. Technically based in Del Rio, he spent most of his time in the Rio Grande Valley during the bloody "Bandit War" of 1915. Onetime sheriff of Caldwell County, Sanders served in the Rangers from 1911 to 1919.

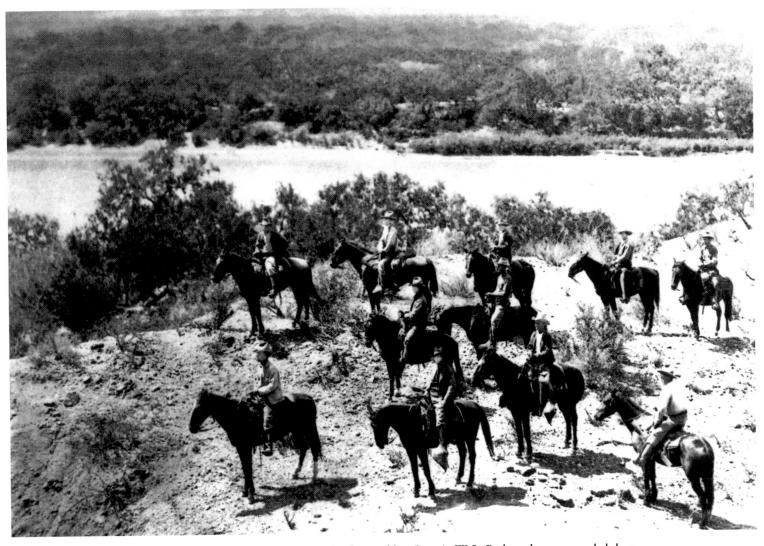

Company E, Texas Rangers, during the early-twentieth-century border troubles. Captain W. L. Barler, who commanded the tenman company, served in the Rangers from 1915 to 1919 and again in 1921-22.

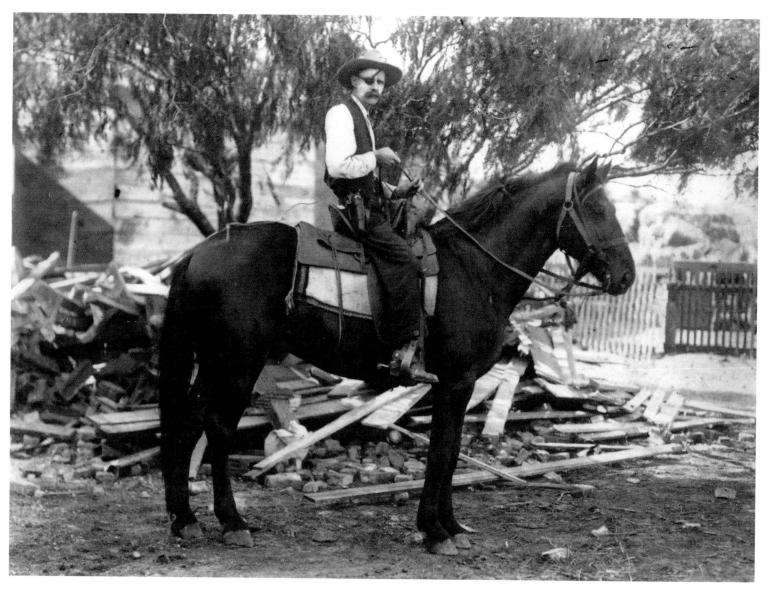

Kleberg County deputy sheriff Bob Kivlin. When former Lee County sheriff James S. Scarborough got elected sheriff in Kleberg County, he recruited Kivlin from his home county in Central Texas. Why Kivlin was wearing an eye patch when this photograph was taken is not known.

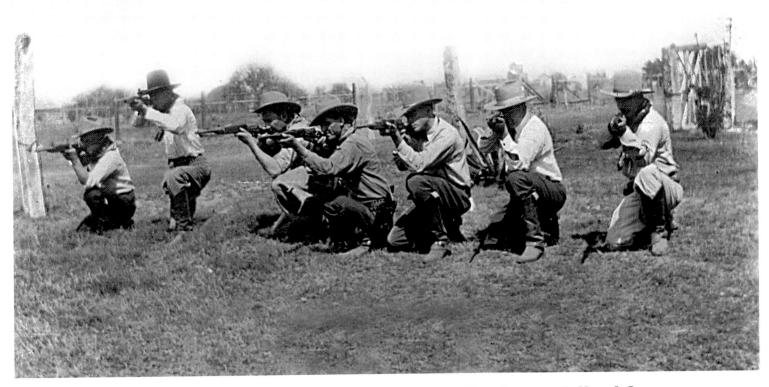

Hundreds of Mexicans died along the border when the Mexican Revolution bled over into Texas. Ranger captain Henry L. Ransom summarily executed prisoners in a manner that came to be called "Ransomizing." Finally transferred out of the Rio Grande Valley, Ransom ended up being accidentally shot to death in Sweetwater in 1918. Left to right are Mason Rountree, Bert Veale, O. D. Cardwell, Cleve Heart, William Almond Shely, Captain Ransom, and John J. Edds.

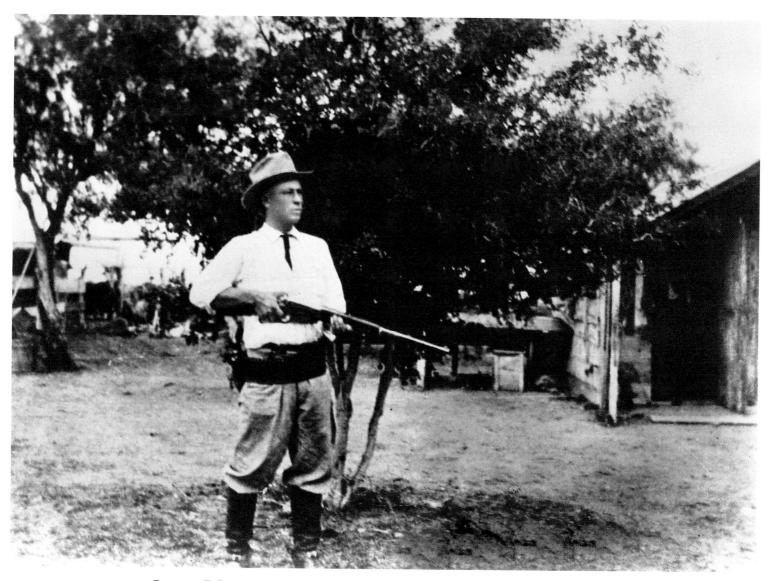

Company D Ranger private Mason Rountree at Pharr. Records show he served in 1915-16. In addition to his six-shooter, he is holding a Winchester Model 95.

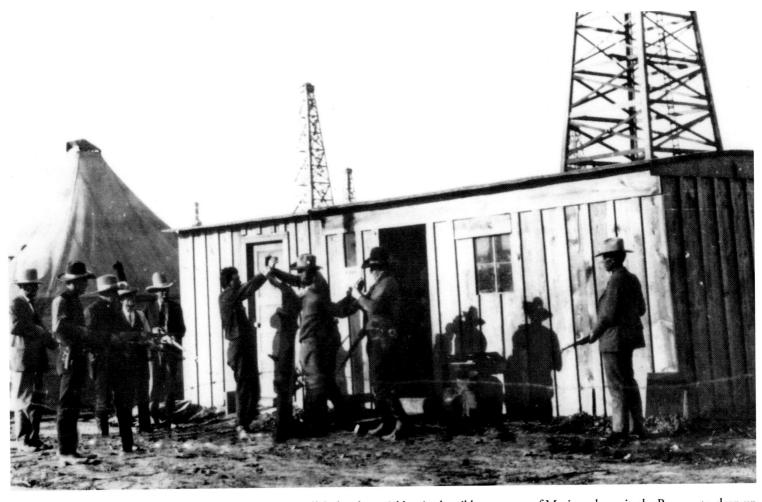

On January 7, 1922, Governor Pat Neff declared martial law in the oil boom town of Mexia and sent in the Rangers to clean up the town. Rangers closed gambling joints, seized illegal liquor, and shut down moonshiners.

CHAPTER FOUR

(1920-1940)

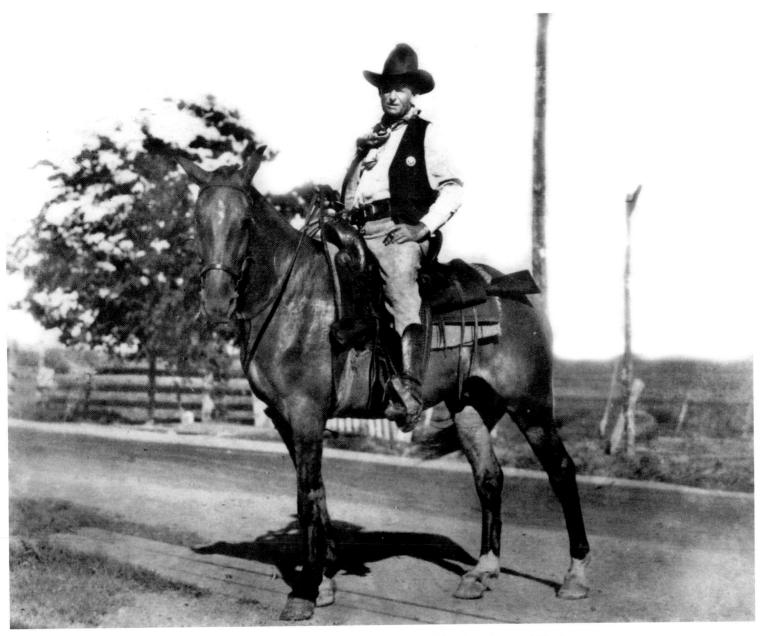

A Ranger scouts a rural road in Limestone County following the imposition of martial law in and around Mexia.

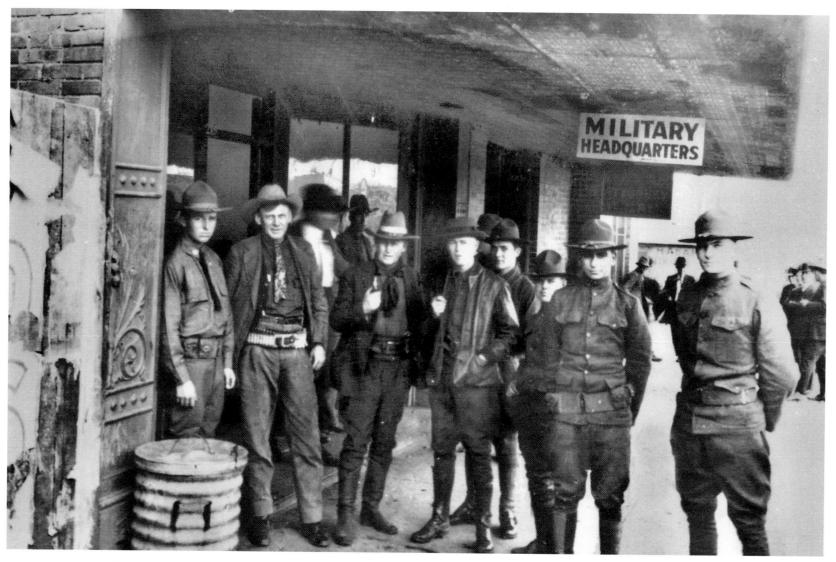

Rangers and two Texas National Guardsmen stand outside military headquarters in Mexia following the state takeover of the teeming oil town.

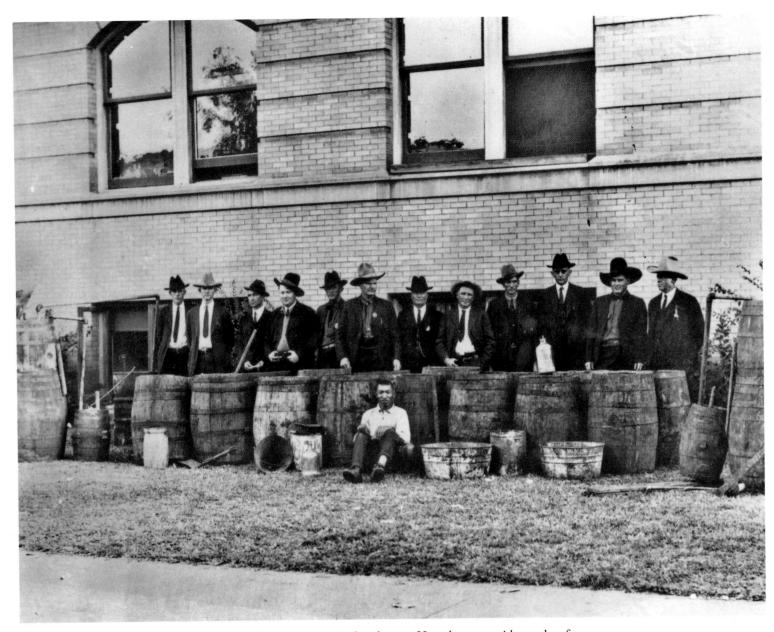

During Prohibition, the Rangers spent a lot of their time pursuing bootleggers. Here they pose with a cache of illegal booze seized near Tyler in Smith County on November 9, 1922.

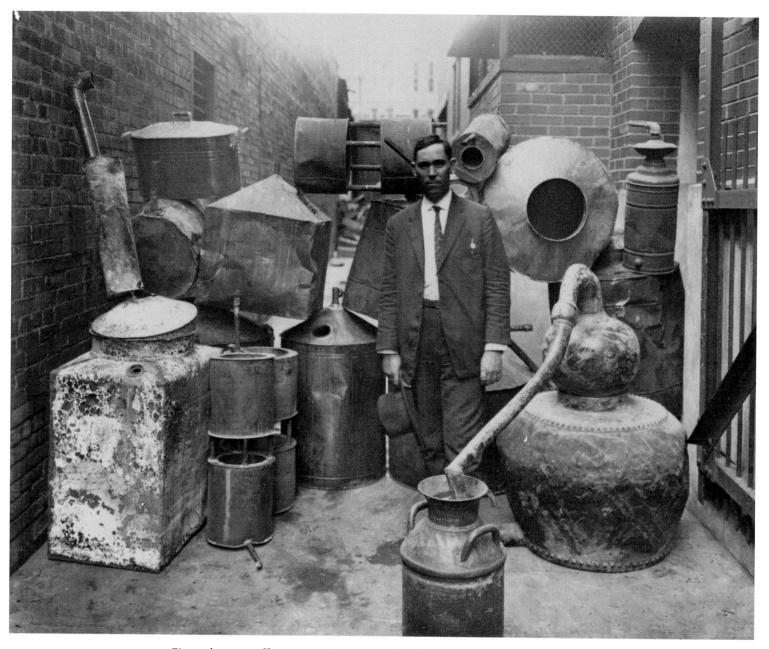

City and county officers across the state seized and destroyed warehouses full of bootleg liquor and broke up distilling operations. These are stills discovered in the Dallas area in the early 1920s.

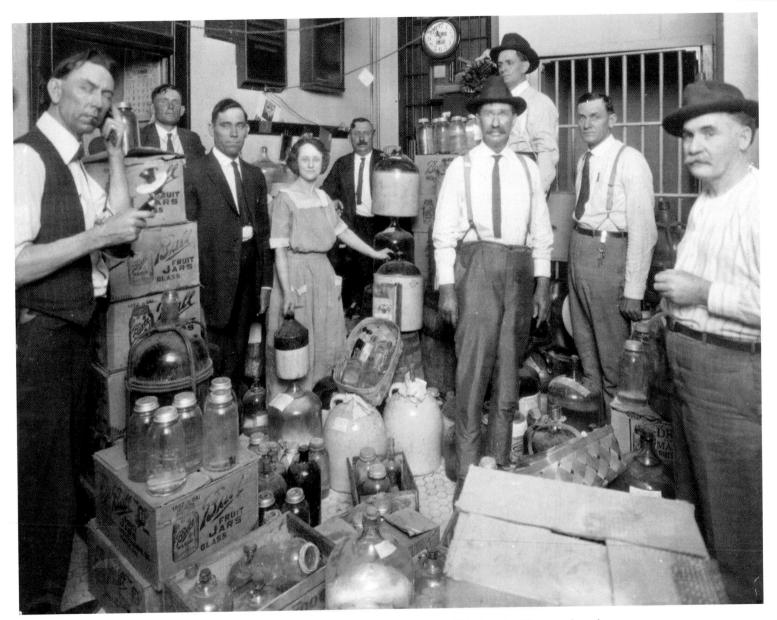

When officers made a prohibition raid, they cheerfully posed for pictures. Publicity could help a sheriff get re-elected, depending on how the majority of his constituents felt about the state and national effort to rid the nation of the problems associated with alcohol consumption.

By 1923, when this photograph was taken, most customers who patronized this East Texas cafe arrived in Model T's. But these five rangers dropped by on horseback. Left to right are Buck Weaver, Roy Hardesty, Sergeant Martin N. Koonsman, Warren Belcher, and Tip Eades.

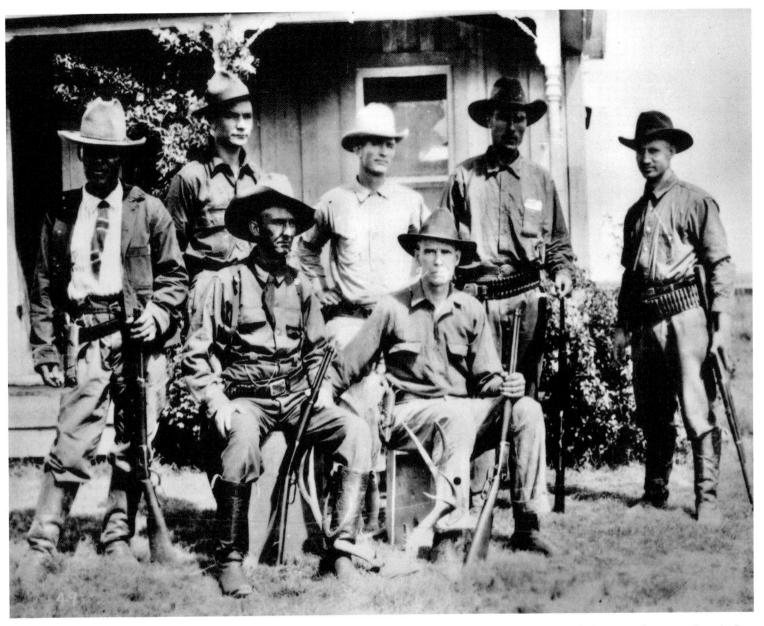

Six members of Texas Ranger Company A at Marathon, in far west Texas. At right is a seventh ranger, Captain Roy W. Aldrich, the Austin-based quartermaster.

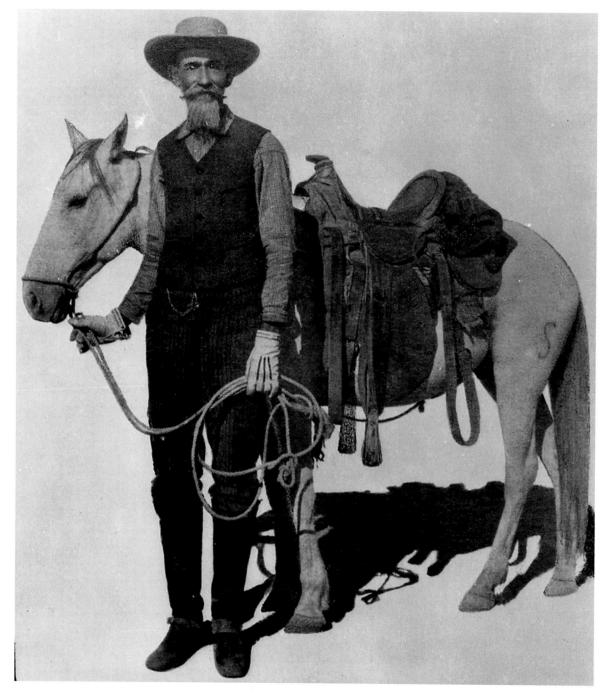

While rangers in Texas looked for bank robbers and bootleggers, newspapers in Arizona ran page-one stories about the death of Henry Mims on Christmas Day, 1925, in Globe. A former ranger, Mims had been scalped by Indians near Duncan Prairie, Texas, in 1865. Despite that trauma, Mims lived to be 109 years old, seldom removing the skull cap that covered his scarred head.

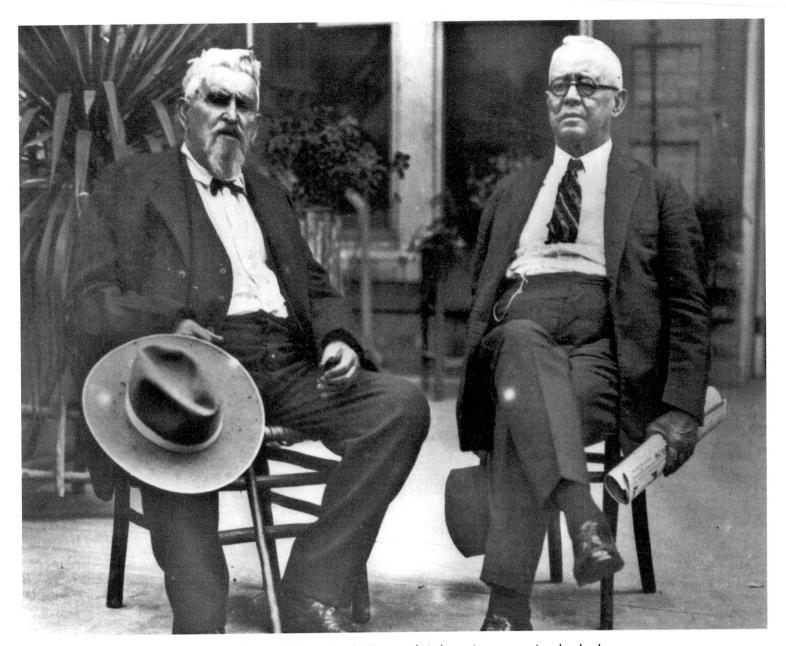

Charles Goodnight, the pioneer credited with virtually inventing the Texas cattle industry (not to mention the chuck wagon), visits with W. D. Reynolds before heading for San Antonio and the annual Old Trail Drivers Reunion. Goodnight served twice as a Texas Ranger, in 1860 and later in 1866.

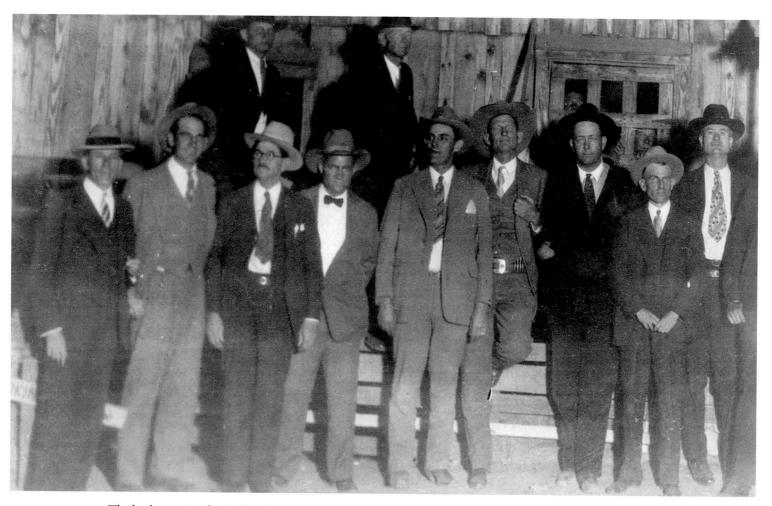

The lawlessness in the Panhandle oilfield town of Borger made Mexia look like a revival meeting. In the spring of 1927, Governor Dan Moody declared martial law there and sent in coat-and-tie-clad Rangers and National Guardsmen. In the foreground, standing fifth, sixth, and seventh from left are cigar-chewing Captain Tom Hickman, lapel-holding Captain W. W. "Bill" Sterling, and a grim-faced Captain Frank Hamer. The short man next to him is Borger's mayor.

Western writer Eugene Cunningham (1896–1957), who interviewed many old-time Texas lawmen and rangers, displays an ivory-handled .45-caliber Colt revolver used by George Parker (far better known as Butch Cassidy) during much of his bank and train robbing career. Parker had traded the pistol to El Paso rancher W. D. Connell in 1906 in Argentina.

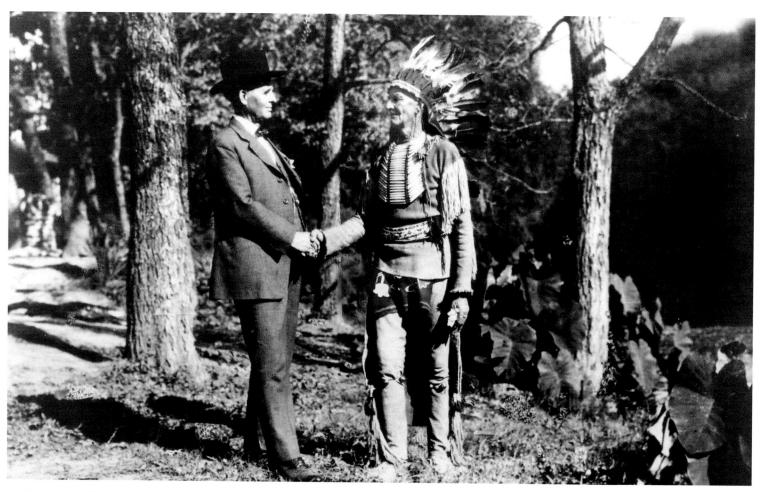

In 1924, former Ranger J. B. Gillett attended the annual reunion of the Old Trail Drivers Association in San Antonio. While there, he met and got his picture taken with former Indian captive Herman Lehman, in war bonnet at right. Forty-nine years earlier, in 1875, the two had faced each other in battle in West Texas. Lehman had been captured by Comanches as a child, into whose culture he had assimilated before his return to society.

Throughout the 1920s and into the early 1930s, Texas rancher J. Frank Norfleet (1864–1967) spent most of his time tracking down con artists who preyed on the gullible. He embarked on his mission after being swindled out of \$45,000 by smooth-talking grifters in Fort Worth in 1919. Unlike most scam victims, Norfleet traveled across the nation pursuing the grifters and had the satisfaction of seeing them sent to prison. Then, just because, he offered his services to other victims.

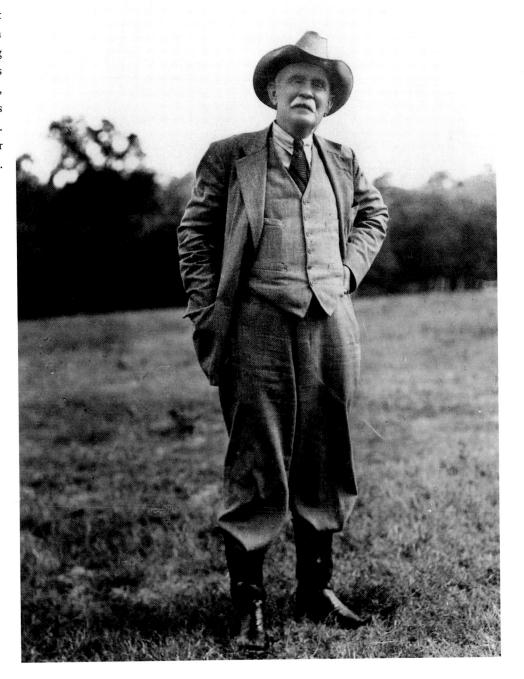

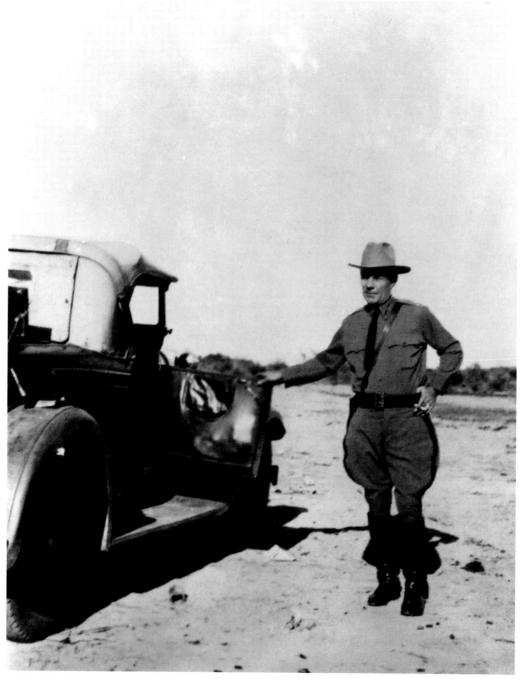

Captain Albert Hausser, U.S. Customs Patrol chief, on a visit to the Laredo area in March 1930. While local and state lawmen handled criminal law enforcement, federal officers enforced immigration statutes and kept an eye out for smugglers of liquor and drugs.

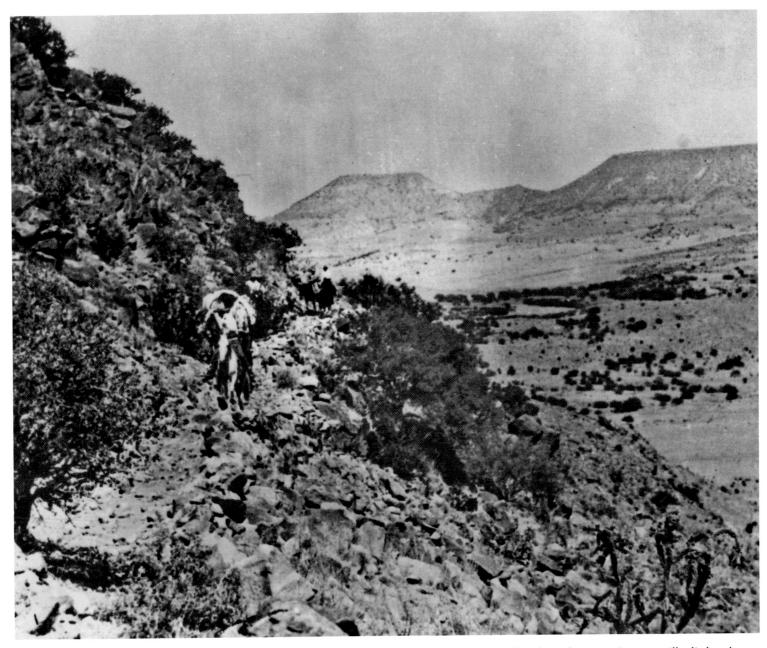

Most roads in West Texas, particularly in the Big Bend, remained unpaved in the early 1930s. Rangers still relied on horses when they needed to work in the more remote areas.

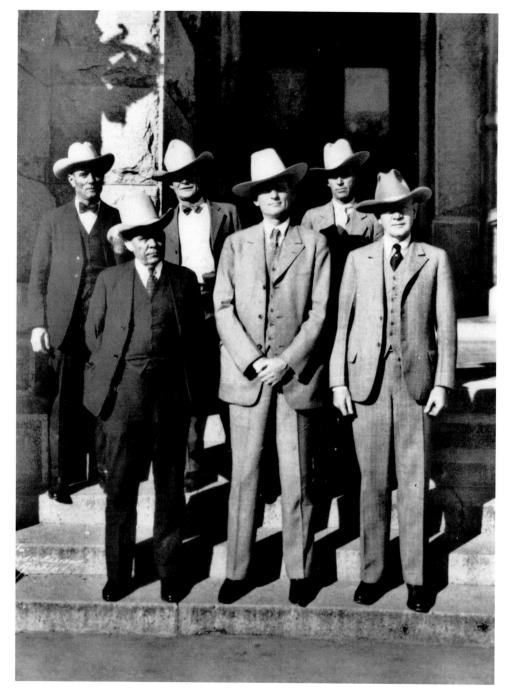

The Texas Rangers were part of the state Adjutant General's Department. In 1931, following the election of Governor Ross Sterling, he appointed W. W. "Bill" Sterling as adjutant general. The first ranger to move into that job up through the ranks, Sterling (lower center) is shown with rangers John Sadler, T. L. Heard, and W. L. Smith (top row), and Captain Light Townsend and chaplain Pierre Hill, on the steps of the Capitol.

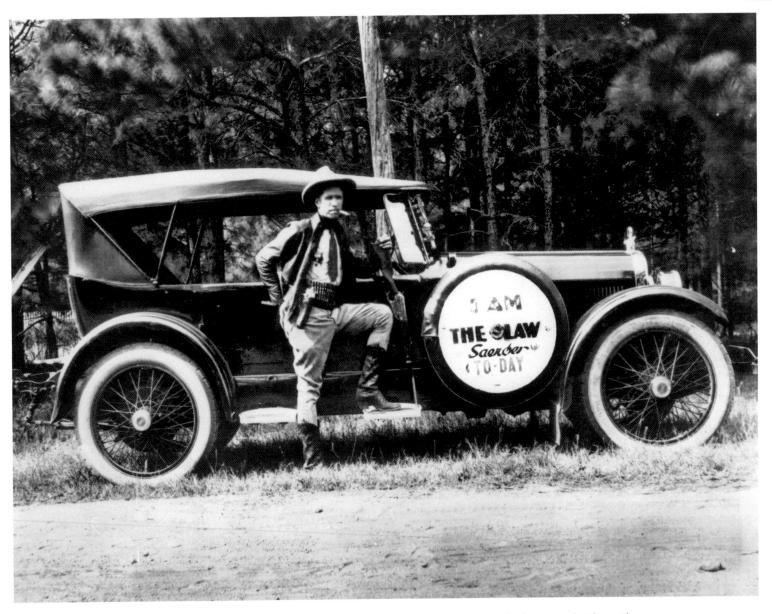

When drilling began in East Texas in 1930, the area around Kilgore and Longview soon grew into the largest and richest oil field in the world. Once again, Rangers were called to deal with rowdy roughnecks and criminals hoping to make money without getting their hands greasy. Shown here is Ranger Manuel Trazazas "Lone Wolf" Gonzaullas' automobile with its tire cover reading "I Am the Law . . . To-day."

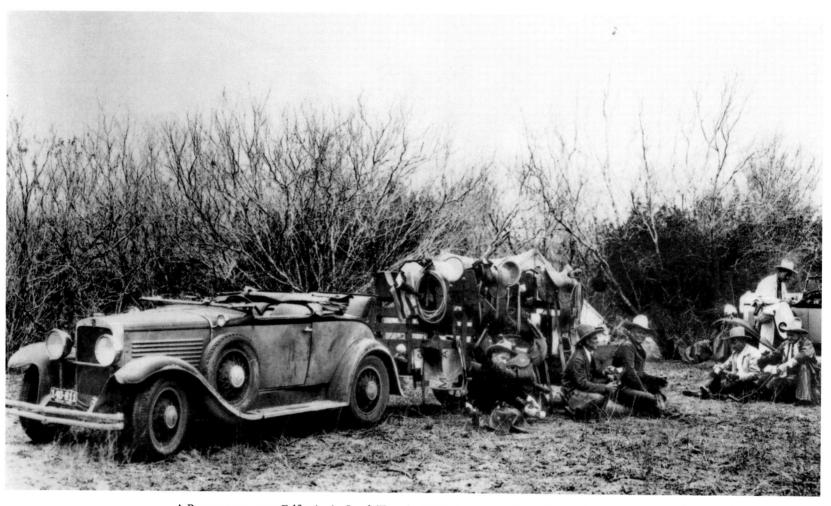

A Ranger camp near Falfurrias in South Texas in 1932. An automobile could get the state lawmen to the general vicinity of where they were needed, but they still required horses to work the brush country.

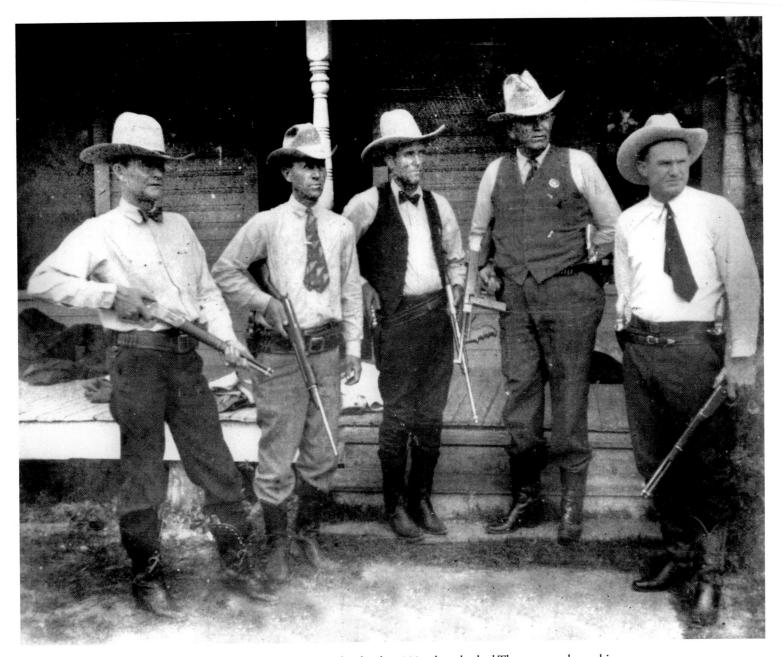

Pistols and rifles remained the primary weapons of the Rangers, but by the 1930s, they also had Thompson sub-machine guns at their disposal. This is a group of unidentified rangers somewhere in South Texas.

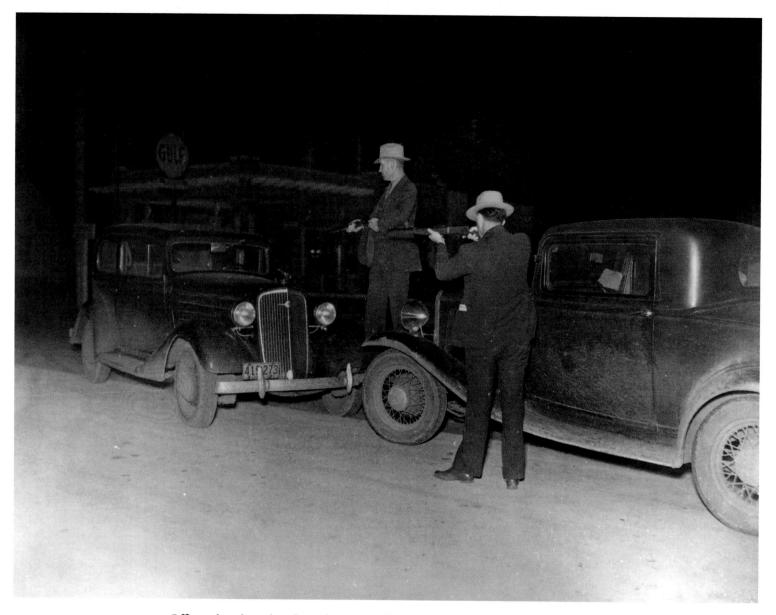

Officers show how they threw down on outlaw Raymond Hamilton and "Teddy" Brooks when they arrested them at a roadblock south of Sherman following a bank robbery on April 25, 1934. "Don't shoot, boys," Hamilton told them. "I'm fresh out of guns, ammo, whiskey, and women." Actually, he still had two pistols on him but facing long arms, decided not to try to use them.

Texas' premier Depression-era outlaws, gun moll Bonnie Parker and her lover and running buddy, Clyde Barrow. This photograph was taken in late March 1933. They stole the Ford behind them a week or so earlier in Marshall.

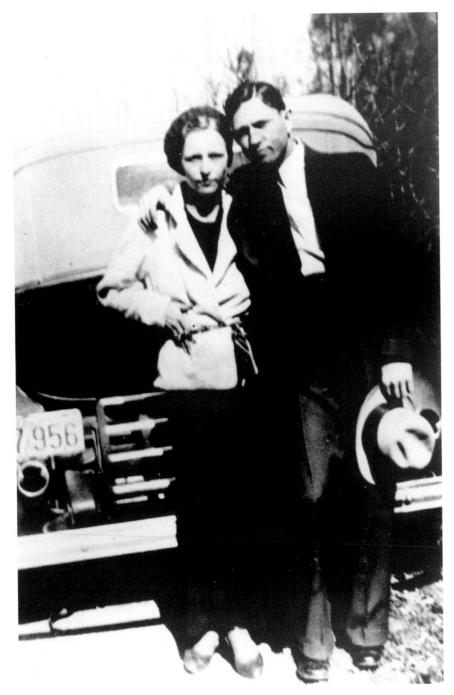

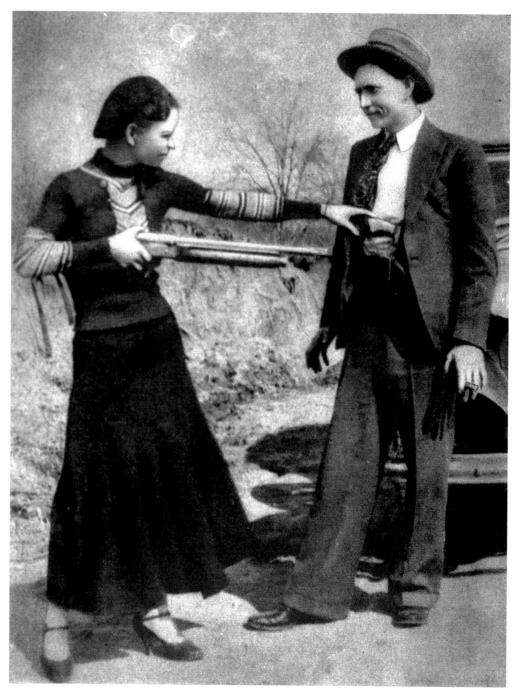

This is perhaps the most famous photograph of Bonnie and Clyde, shown here clowning around with a deadly sawed-off shotgun. They enjoyed the attention they got in the news media, but Texas lawmen led by former Ranger captain Frank Hamer were hot on their trail.

Dallas thug Clyde Barrow liked to pose for photographs. He also liked to rob banks and did not mind shooting people who got in his way. The hole in the "Curve" sign he's sticking his hand through in this image must have taken several shots to get that big.

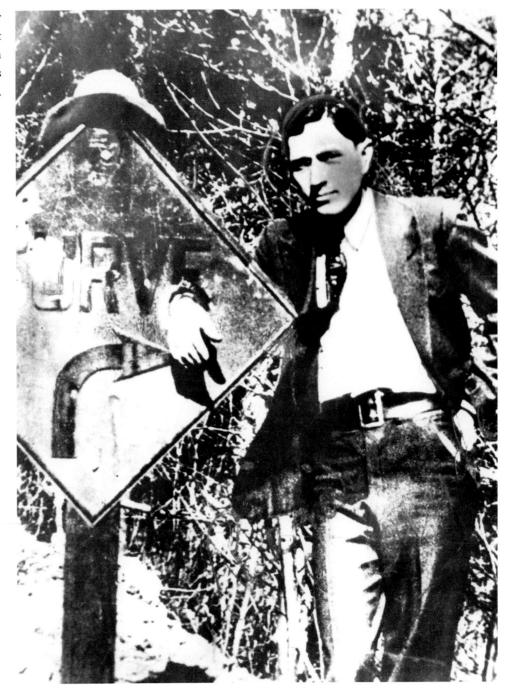

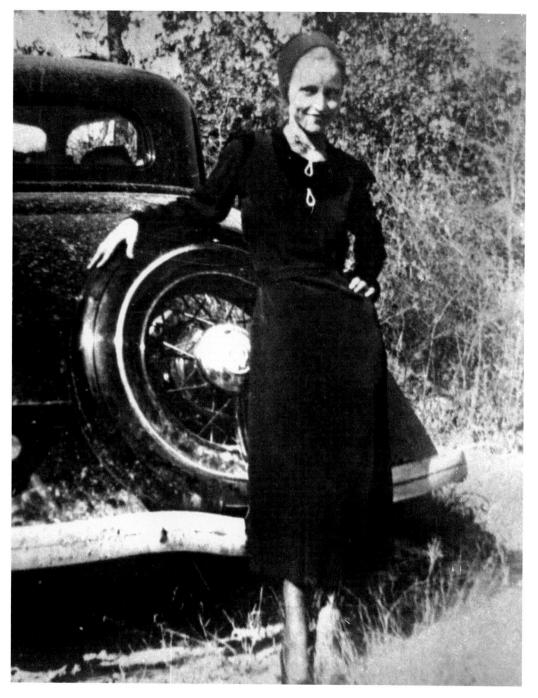

Bonnie Parker, born in the small West Texas town of Rowena, had a fondness for men and fast cars. When she paired off with Clyde Barrow, the couple soon became known nationwide simply as Bonnie and Clyde.

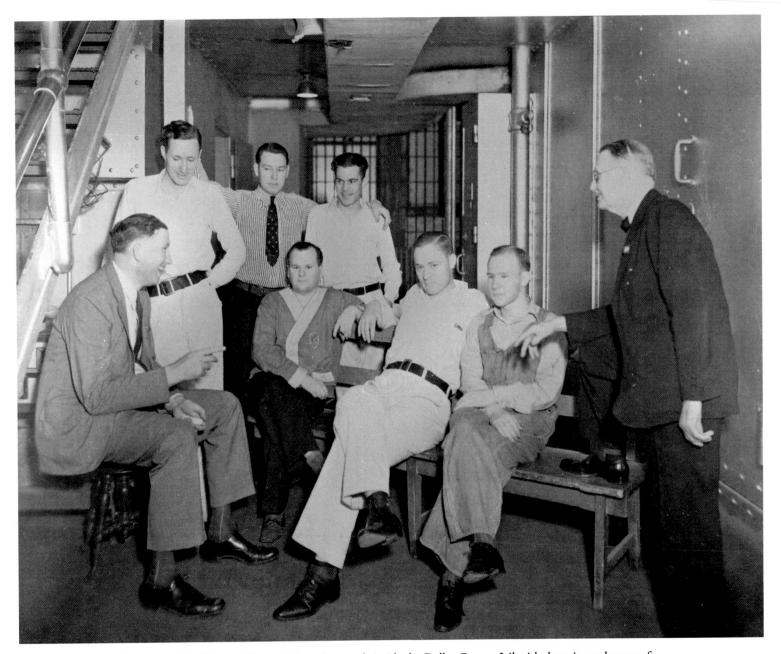

Dallas County sheriff Richard Allen "Smoot" Schmid, far right, stands inside the Dallas County Jail with deputies and some of his "guests," including Roy Thornton, Bonnie Parker's husband. This image was recorded June 2, 1933.

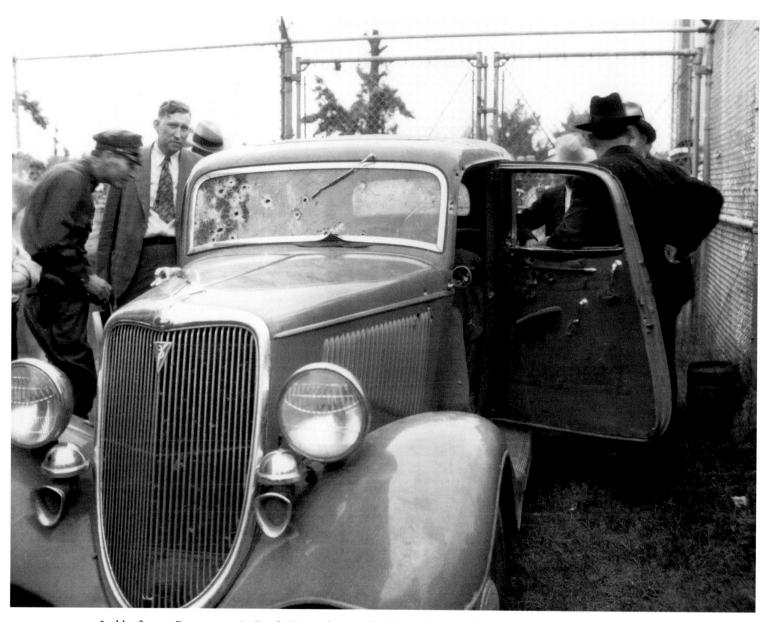

Led by former Ranger captain Frank Hamer, lawmen finally caught up with Bonnie and Clyde near Arcadia, Louisiana, in Bienville Parish on May 23, 1934. This is the bullet-riddled Ford the couple died in after it had been towed back to the county seat.

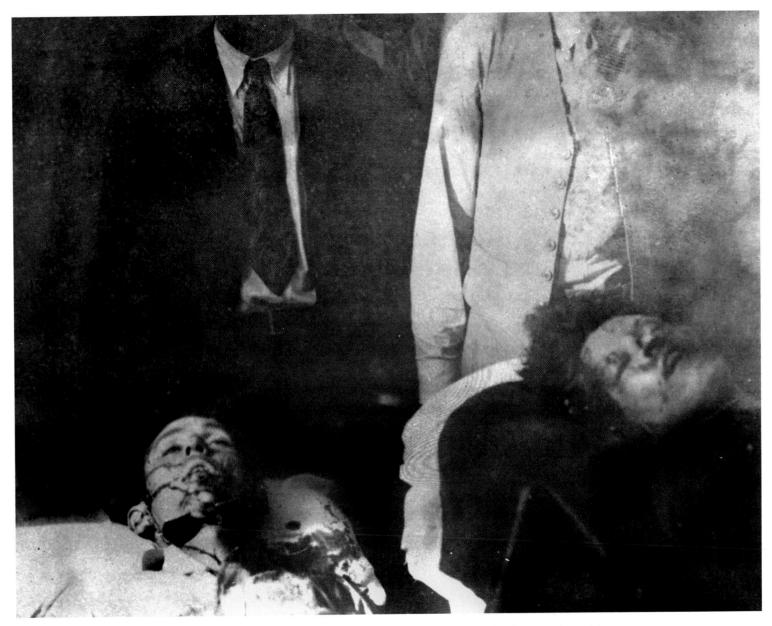

The late Clyde Barrow (left) and Bonnie Parker before the undertaker in Arcadia, Louisiana, had a chance to begin his cosmetic work. The couple were buried in Dallas. Hundreds attended both funerals.

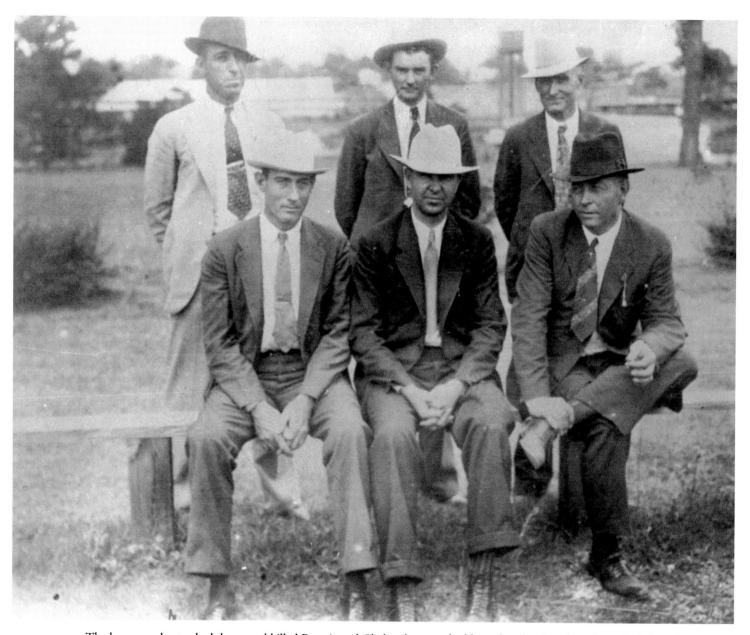

The lawmen who tracked down and killed Bonnie and Clyde, photographed later that day. Standing, from the left, Dallas County deputy sheriff Ted Hinton, Bienville Parish deputy Prentis Oakley, and former Ranger Manny Gault; seated, Dallas deputy Bob Alcorn, Bienville Parish sheriff Henderson Jordan, and Frank Hamer.

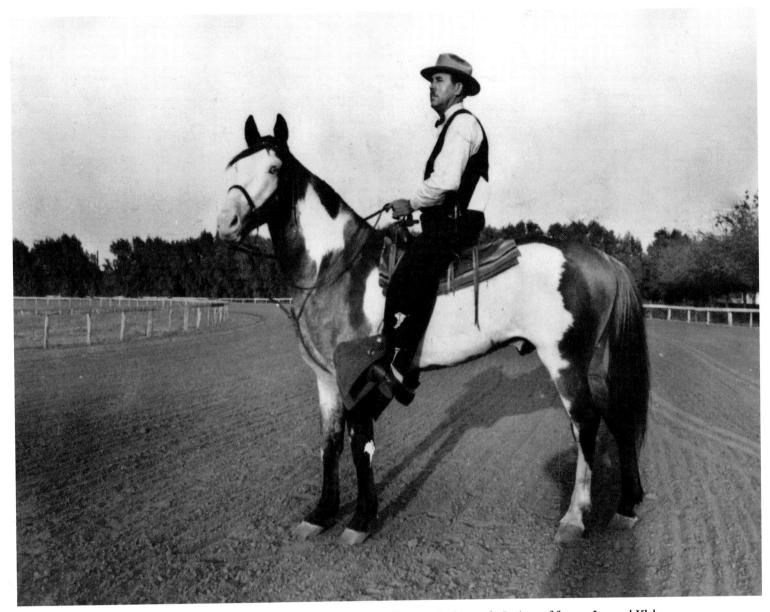

Visiting a racetrack sometime in the 1930s, longtime Kleberg County sheriff James Scarborough, Jr. (son of former Lee and Kleberg county sheriff James Spurgeon Scarborough), sits astride a roan paint he bought in College Station as a gift for his son. Scarborough served from 1935 to 1972. James S. Scarborough III went on to serve as Kleberg County sheriff from 1972 to 1989. In all, three men named James S. Scarborough served as Kleberg County sheriff in Texas for a total of 75 years, 9 months, and 15 days.

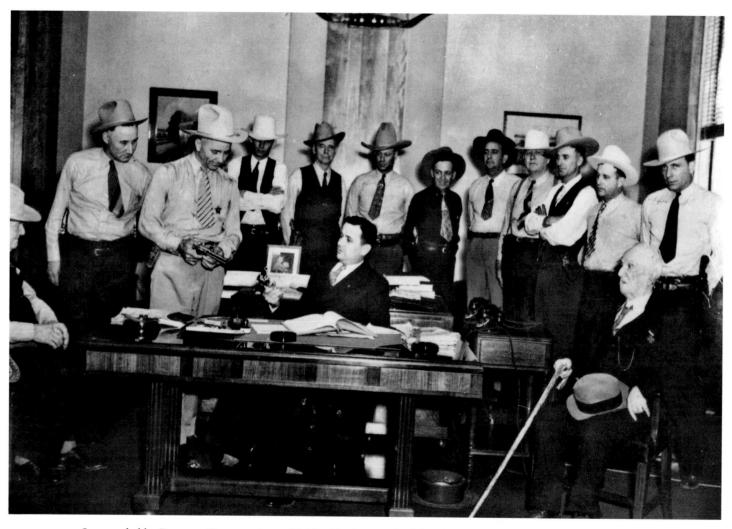

Surrounded by Rangers, Governor James V. Allred looks at a pistol they have presented him. When he ran for governor in 1934, Allred promised to push for a modern state police force. Seven months after he took office, the new Texas Department of Public Safety began its operations. The Rangers and Highway Patrol were transferred from the Adjutant General's Office and Highway Department to fashion the new law enforcement agency, which would also include a modern crime laboratory.

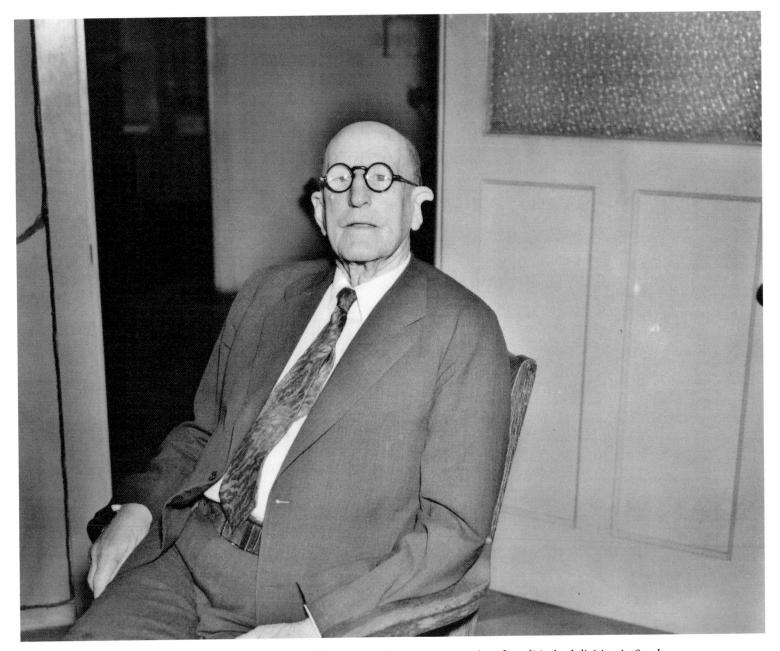

After leaving the Rangers, Captain J. A. Brooks (1855–1944) went on to become county judge of a political subdivision in South Texas named in his honor—Brooks County. Judge Brooks is shown here on a visit to San Antonio in the spring of 1937.

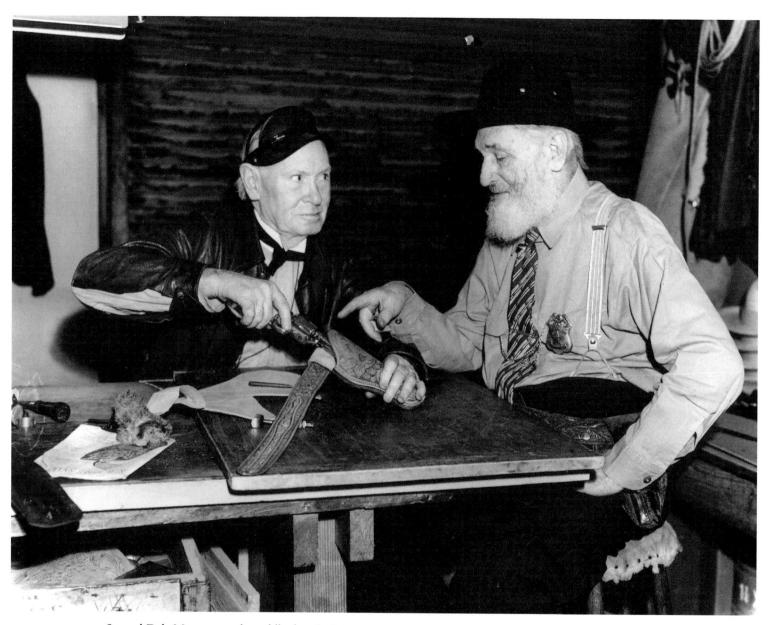

Samuel Dale Myres opened a saddle shop in Sweetwater in 1898 and continued to craft leather, especially scabbards for pistols and rifles, for most of the rest of his life. In 1920, he moved to El Paso, where one of his customers was former Ranger captain John R. Hughes, at right. This photo was taken by former newspaperman L. A. Wilke, a friend of both men.

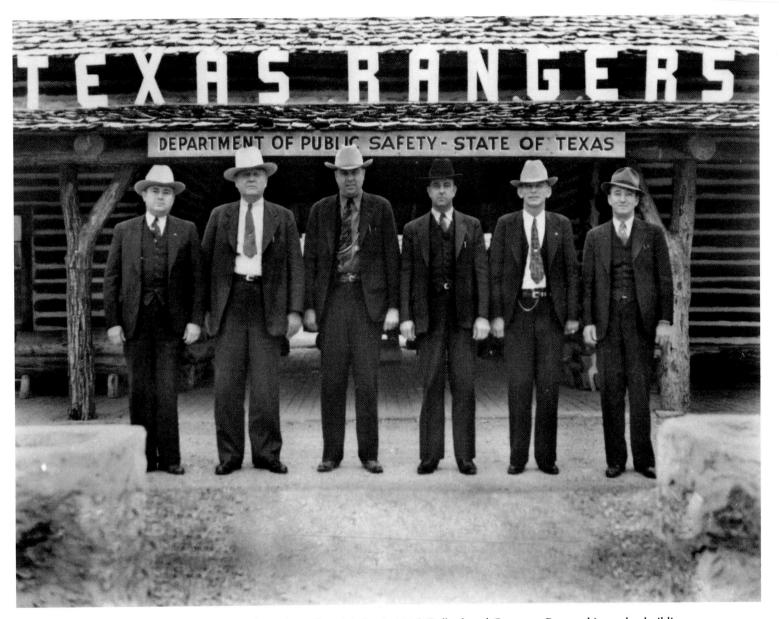

When Texas celebrated one hundred years of independence from Mexico in 1936, Dallas-based Company B moved into a log building on the State Fair of Texas grounds that continued as its headquarters into the 1960s. Posing for a group shot on November 22, 1938, are, from the left, Captain Royal G. Phillips, F. W. Albright, Levi Duncan, Ernest Daniel, C. G. Rush, and R. L. Badgett.

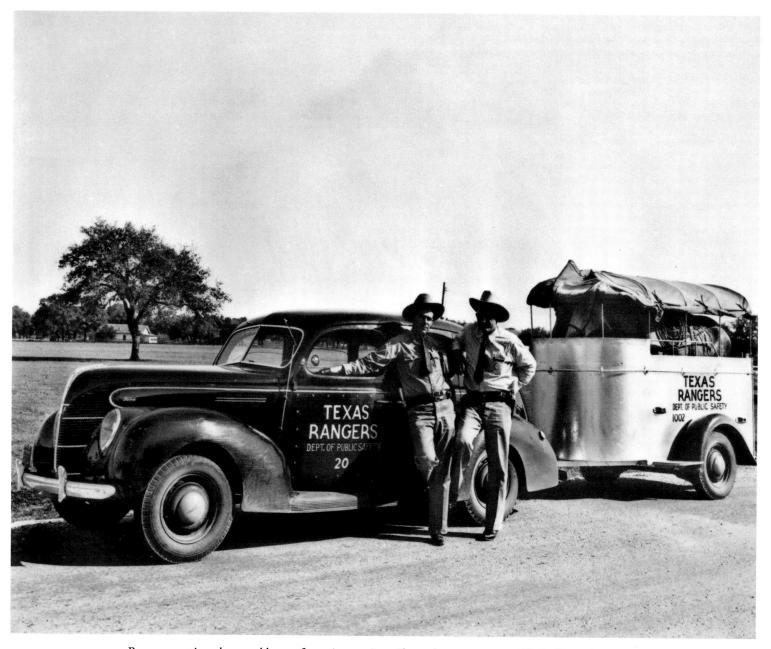

Rangers continued to need horses from time to time. Shown here are rangers Alfred Allee and Ab Riggs (right) and their 1939 vintage state-furnished car and trailer.

Mitchell County deputy sheriff and tax collector M. G. "Blaze" Delling on December 7, 1940.

Delling had seen it all as a state, federal, and county officer. He served as a Texas Ranger from 1898 to 1906, as a U.S. Customs inspector from 1906 to 1911, and later as a U.S. Immigration inspector.

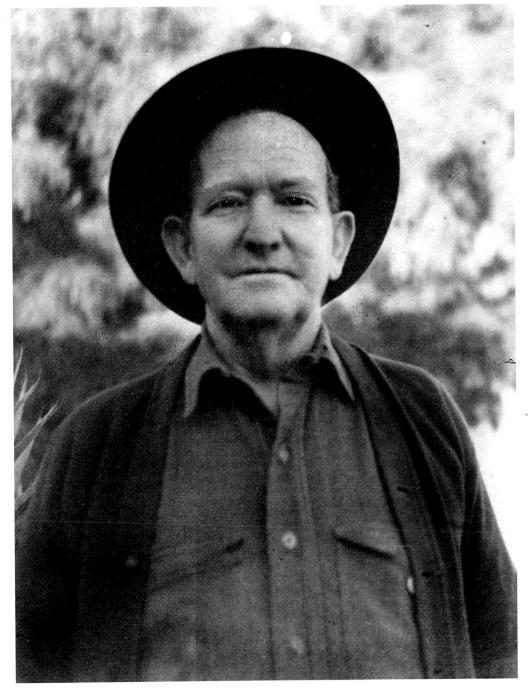

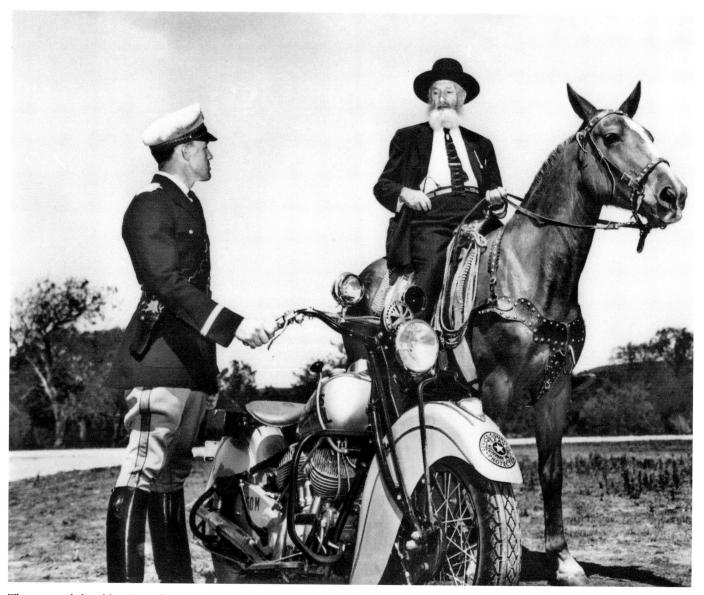

The new and the old in Texas law enforcement. At left, a uniformed Highway Patrolman and his two-wheeler; at right, Captain John Hughes sits astride the type of four-legged transportation he relied on as a border Ranger. Captain Hughes first rode as a ranger in 1887, living long enough to see a new era in Texas law enforcement. Seven years after these photos were taken, ill and having outlived most of his old friends, he used the pearl-handled pistol he once carried as a ranger to kill himself.

NOTES ON THE PHOTOGRAPHS

These notes, listed by page number, attempt to include all aspects known of the photographs. Each of the photographs is identified by the page number, a title or description, photographer and collection, archive, and call or box number when applicable. Although every attempt was made to collect all data, in some cases complete data may have been unavailable due to the age and condition of some of the photographs and records.

- II MILITARY PLAZA
 Library of Congress
 LC-DIG-ppmsca-10494
- VI DEL RIO, 1890s
 Rose Collection
 Western History Collection
 University of Oklahoma
- x THE ALAMO, 1849
 Rose Collection
 Western History Collection
 University of Oklahoma
- 2 GENERAL BEN
 MCCULLOCH
 Rose Collection
 Western History Collection
 University of Oklahoma
 1222
- Asa Sowell
 Rose Collection
 Western History Collection
 University of Oklahoma
 400
- 4 EUSTACE BENTON
 Rose Collection
 Western History Collection
 University of Oklahoma
 421

- 5 HANGING OF BOB AUGUSTINE Library of Congress LC-USZ62-55947
- 6 ANDREW JACKSON
 SOWELL
 Rose Collection
 Western History Collection
 University of Oklahoma
 1414
- 7 COMPANY B, 1870s
 Rose Collection
 Western History Collection
 University of Oklahoma
 1405

8

9

- PAT DOLAN
 Rose Collection
 Western History Collection
 University of Oklahoma
 1403
- QUARTERS
 Rose Collection
 Western History Collection
 University of Oklahoma
 1462

CAPTAIN ROBERTS

- 10 CAMP LEISURE
 Rose Collection
 Western History Collection
 University of Oklahoma
 1464
- 11 Hoo-Doo WAR SITE
 Rose Collection
 Western History Collection
 University of Oklahoma
 527
 - 2 JOHN SELMAN
 Rose Collection
 Western History Collection
 University of Oklahoma
 2137
 - **DUTY**Rose Collection
 Western History Collection
 University of Oklahoma
 1440

JAMES GILLETT AND

13

14 DEL RIO, 1880
Rose Collection
Western History Collection
University of Oklahoma
534

- From the collections of the Texas/Dallas History and Archives Division, Dallas Public Library Ragland PA92-10/4
- 17 DALLAS STOUDENMIRE
 Rose Collection
 Western History Collection
 University of Oklahoma
 1769

18

MARSHAL
Rose Collection
Western History Collection
University of Oklahoma
1933

GILLETT AS EL PASO

19 CONGRESS AVENUE,
AUSTIN
Rose Collection
Western History Collection
University of Oklahoma
135

- 20 RANGERS IN TASCOSA
 University of Texas at San
 Antonio, Institute of Texan
 Cultures
 073-0378
- 21 John "King" Fisher
 Rose Collection
 Western History Collection
 University of Oklahoma
 2152
- 22 FRONTIER BATTALION,
 COMPANY F
 Rose Collection
 Western History Collection
 University of Oklahoma
 1409
- RANGERS GROUP SHOT
 Rose Collection
 Western History Collection
 University of Oklahoma
 1450

24

PANHANDLE
Forbes Collection
Western History Collection
University of Oklahoma
14

HERDING HORSES IN

6			
25	EDWARD SCOTTEN Rose Collection Western History Collection University of Oklahoma 1786	33	RANGERS AT COTULLA GROCERY University of Texas at San Antonio, Institute of Texan Cultures 073-0480
26 27	EL PASO LONE STAR Rose Collection Western History Collection University of Oklahoma 554 SHERIFF R. R.	34	MARSHAL JIM COURTRIGHT Rose Collection Western History Collection University of Oklahoma 2110
	RUSSELL Rose Collection Western History Collection University of Oklahoma 1640½	35	TEXAS COWBOYS GROUP Rose Collection Western History Collection University of Oklahoma 1608
28	Forbes Collection Western History Collection University of Oklahoma 6	36	RANGER IRA ATEN Rose Collection Western History Collection University of Oklahoma 1453
29	COWBOYS IN CAMP Forbes Collection Western History Collection University of Oklahoma 67	37	GEORGE SCHMITT'S COMPANY Rose Collection Western History Collection

30 PECOS CITY SALOON Rose Collection Western History Collection University of Oklahoma 1947

31 LAMARTINE P. SIEKER University of Texas at San Antonio, Institute of Texan Cultures 099-0178

32 TEXAS COWBOY, 1880s Rose Collection Western History Collection University of Oklahoma 1609

40 SAM McMurry's COMPANY AT THURBER Rose Collection Western History Collection University of Oklahoma 1478

41

42

46

University of Oklahoma

Western History Collection

University of Oklahoma

University of Texas at San

Antonio, Institute of Texan

COMPANY D AT

TERRY'S TEXAS

RANGERS

Cultures

102-0193

Rose Collection

REALITOS

1412

1408

38

39

BEXAR COUNTY JAIL Rose Collection Western History Collection University of Oklahoma 216

BEXAR COUNTY JAIL NO. 2 Rose Collection Western History Collection University of Oklahoma 215

RANGERS AT SHAFTER Rose Collection Western History Collection University of Oklahoma 1443

RANGERS AT LEONA RIVER CAMP University of Texas at San Antonio, Institute of Texan Cultures 073-0372

RANGERS AT AMARILLO University of Texas at San Antonio, Institute of Texan Cultures 073-0369

RANGERS IN SOUTH

TEXAS Rose Collection Western History Collection University of Oklahoma 1456

47 RANGERS ON BRIDGE University of Texas at San Antonio, Institute of Texan Cultures 073-0392

FIRE WATER

48

52

53

ADVERTISING Rose Collection Western History Collection University of Oklahoma 1932

49 RANGERS DURING RAILROAD STRIKE Rose Collection Western History Collection University of Oklahoma 1479

50 ROY BEAN AND 58 CHILDREN San Antonio Light Collection 1508-B 51 RANGERS AT YSLETA

Rose Collection Western History Collection University of Oklahoma 1451

LEN DRIVER Rose Collection Western History Collection University of Oklahoma 430

RANGERS AT YSLETA

MANNIE CLEMENTS AND

WITH PRISONER Rose Collection Western History Collection University of Oklahoma

1442

54 J. H. McMAHAN Rose Collection Western History Collection University of Oklahoma 1470

55 RANGERS OPPOSING PRIZEFIGHT Rose Collection Western History Collection University of Oklahoma 1472

A. J. SOWELL AND

56

57

59

60

61

FAMILY MEMBERS Rose Collection Western History Collection University of Oklahoma 403

JOHN R. HUGHES Rose Collection Western History Collection University of Oklahoma 1441

MARSHAL CLINE AND INSPECTOR GREEN University of Texas at San Antonio, Institute of Texan Cultures 075-1093

JOHN WESLEY HARDIN. KILLED Rose Collection Western History Collection University of Oklahoma 2136

COMPANY B AT SAN SABA CAMP Rose Collection Western History Collection University of Oklahoma 1482

JUDGE ROY BEAN **OUTSIDE THE JERSEY** LILLY University of Texas at San Antonio, Institute of Texan Cultures 083-871

62 WILLIAM "BIG FOOT" WALLACE

University of Texas at San Antonio, Institute of Texan Cultures 093-72

63 San Antonio Marshal's Office

Rose Collection Western History Collection University of Oklahoma 164

64 Law West of the Pecos

University of Texas at San Antonio, Institute of Texan Cultures 092-302

66 ROY BEAN

University of Texas at San Antonio, Institute of Texan Cultures 1179-A

67 THE JERSEY LILLY, 1900

Library of Congress HABS TEX,233-LANG,1-

68 OLD ROCK SALOON

Rose Collection Western History Collection University of Oklahoma 1934

69 WICHITA FALLS

Rose Collection Western History Collection University of Oklahoma 529

70 HOLE IN THE WALL

Rose Collection Western History Collection University of Oklahoma 2163

71 CAPTURE OF HORSE THIEF CORTEZ

Rose Collection Western History Collection University of Oklahoma 2113

72 MARVIN HUNTER AND ASSOCIATES NEAR MENARD

Rose Collection Western History Collection University of Oklahoma 298

73 CAMP AT COLORADO, TEXAS

Rose Collection Western History Collection University of Oklahoma 1519

74 Tom Young

Rose Collection Western History Collection University of Oklahoma 2111

75 DEL RIO MAIN STREET, 1906

Rose Collection Western History Collection University of Oklahoma 535

76 Cowboys at Dinner, LS Ranch

Library of Congress LC-DIG-ppmsca-08793

77 VAL VERDE COUNTY SHERIFF AND DEPUTIES

Rose Collection Western History Collection University of Oklahoma 1796

78 RANGERS AT BIG BEND 85 University of Texas at San Antonio, Institute of Texan

Cultures 073-0366

79 Mollie Bailey Circus AT Lockney

Rose Collection Western History Collection University of Oklahoma 451

80 James S. Scarborough

University of Texas at San Antonio, Institute of Texan Cultures 100-0555

81 FORT WORTH PANORAMA

Library of Congress LC-USZ62-122801

82 Plan of San Diego Raiders, Killed

University of Texas at San Antonio, Institute of Texan Cultures 073-0473

83 On the Trail of Mexican Bandits

University of Texas at San Antonio, Institute of Texan Cultures 073-0404

84 BERT CLINTON VEALE

Rose Collection Western History Collection University of Oklahoma 1502

GUARDING THE RIO GRANDE

Rose Collection Western History Collection University of Oklahoma 1806

86 TEXAS RANGER ON HORSEBACK

Rose Collection Western History Collection University of Oklahoma 1558

87 CAPTAIN JOHN SANDERS AND COMPANY A

Rose Collection Western History Collection University of Oklahoma 1471

88 Texas Rangers, Company E

University of Texas at San Antonio, Institute of Texan Cultures 073-0385

89 BOB KIVLIN, KLEBERG COUNTY DEPUTY SHERIFF

University of Texas at San Antonio, Institute of Texan Cultures 100-0570

90 CAPTAIN HENRY RANSOM AND RANGERS

Rose Collection Western History Collection University of Oklahoma 1530

91 MASON ROUNTREE

Rose Collection Western History Collection University of Oklahoma 1531

92 RANGERS AT MEXIA University of Texas at San Antonio, Institute of Texan

Cultures 073-0486

PA RANGER ON HORSEBACK AT MEXIA

University of Texas at San Antonio, Institute of Texan Cultures 073-0490

95 RANGER HEADQUARTERS AT MEXIA

University of Texas at San Antonio, Institute of Texan Cultures 073-0485

96 Confiscated Bootles Liquor, near Tyler

University of Texas at San Antonio, Institute of Texan Cultures 073-0412

97 CONFISCATED STILL, AT DALLAS

From the collections of the Texas/Dallas History and Archives Division, Dallas Public Library Frank Rogers Collection PA78-2-1312

98 OFFICERS WITH CONFISCATED BOOTLEG LIQUOR

From the collections of the Texas/Dallas History and Archives Division, Dallas Public Library Frank Rogers Collection PA78-2-555

99 RANGERS ON HORSEBACK IN EAST TEXAS, 1923

University of Texas at San Antonio, Institute of Texan Cultures 073-0406

100 COMPANY A AT

University of Texas at San Antonio, Institute of Texan Cultures 073-0414

101 HENRY MIMS

Rose Collection Western History Collection University of Oklahoma 1407

102 CHARLES GOODNIGHT AND WILLIAM DAVID REYNOLDS

University of Texas at San Antonio, Institute of Texan Cultures 100-0366

103 RANGERS AT BORGER

Rose Collection Western History Collection University of Oklahoma 1535

104 EUGENE CUNNINGHAM

Rose Collection Western History Collection University of Oklahoma 399

105 J. B. GILLETT AND HERMAN LEHMAN AT REUNION

Rose Collection Western History Collection University of Oklahoma 954

106 J. FRANK NORFLEET

Rose Collection Western History Collection University of Oklahoma 1787

107 CAPTAIN ALBERT HAUSSER

Rose Collection Western History Collection University of Oklahoma 1803

108 RANGERS ON MOUNTAIN TRAIL

University of Texas at San Antonio, Institute of Texan Cultures 073-0389

109 W. W. "BILL" STERLING WITH RANGERS AT CAPITOL

University of Texas at San Antonio, Institute of Texan Cultures 073-0374

110 PATROL AT KILGORE AND 117 LONGVIEW

University of Texas at San Antonio, Institute of Texan Cultures 073-0483

111 RANGER CAMP AT FALFURRIAS

University of Texas at San Antonio, Institute of Texan Cultures 073-0411

112 RANGERS IN SOUTH TEXAS, 1933

University of Texas at San Antonio, Institute of Texan Cultures 073-0403

113 DETECTIVES AT HAMILTON CAR

From the collections of the Texas/Dallas History and Archives Division, Dallas Public Library PA76-1/37316

114 BONNIE AND CLYDE

From the collections of the Texas/Dallas History and Archives Division, Dallas Public Library MA83.7/MB.B-32

115 BONNIE AND CLYDE CLOWNING AROUND

Rose Collection Western History Collection University of Oklahoma 2134

116 CLYDE BARROW

Rose Collection Western History Collection University of Oklahoma 2119

BONNIE PARKER

From the collections of the Texas/Dallas History and Archives Division, Dallas Public Library PA76-1-33021

118 SHERIFF "SMOOT" SCHMID WITH DEPUTIES AND "GUESTS"

From the collections of the Texas/Dallas History and Archives Division, Dallas Public Library PA76-1/37306

119 BONNIE AND CLYDE DEATH CAR

From the collections of the Texas/Dallas History and Archives Division, Dallas Public Library PA76-1/33022.1

120 BONNIE AND CLYDE, KILLED

From the collections of the Texas/Dallas History and Archives Division, Dallas Public Library PA96-5/3

121 FRANK HAMER AND FELLOW LAWMEN

From the collections of the Texas/Dallas History and Archives Division, Dallas Public Library PA96-5/7

122 SHERIFF JAMES S. SCARBOROUGH, JR.

University of Texas at San Antonio, Institute of Texan Cultures 100-0569

123 GOVERNOR JAMES ALLRED AND RANGERS

University of Texas at San Antonio, Institute of Texan Cultures 073-0418

124 JUDGE J. A. BROOKS University of Texas at San Antonio, Institute of Texan Cultures 1542-BB

125 SAMUEL MYRES WITH JOHN R. HUGHES Mike Cox Collection

126 TEXAS RANGERS, COMPANY B, 1938

University of Texas at San Antonio, Institute of Texan Cultures 073-0410

127 RANGERS ALFRED ALLEE AND AB RIGGS

University of Texas at San Antonio, Institute of Texan Cultures 073-0479

128 DEPUTY SHERIFF M. G. "BLAZE" DELLING

Rose Collection Western History Collection University of Oklahoma 1402

129 HUGHES WITH HIGHWAY PATROLMAN

University of Texas at San Antonio, Institute of Texan Cultures 073-545

BIBLIOGRAPHY

Brooks, David B. Texas Practice, vol. 35, County and Special District Law. St. Paul, Minn.: West Publishing Co., 1989.

Cox, Mike. The Texas Rangers: Wearing the Cinco Peso, 1821-1900. New York: Forge Books, 2008.

Dixon, James G. The Politics of the Texas Sheriff: From Frontier to Bureaucracy. Boston: American Press, 1983.

Hatley, Allen G. Texas Constables: A Frontier Heritage. Lubbock: Texas Tech University Press, 1999.

Horton, David M., and Ryan Kellus Turner. Lone Star Justice: A Comprehensive Overview of the Texas Criminal Justice System. Austin: Eakin Press, 1999.

Johnson, David R. American Law Enforcement: A History. Wheeling, Ill.: Forum Press, 1981.

O'Neal, Bill. Encyclopedia of Western Gun Fighters. Norman: University of Oklahoma Press, 1979.

Prassel, Frank Richard. The Western Peace Officer: A Legacy of Law and Order. Norman: University of Oklahoma Press, 1972.

Sitton, Thad. Texas High Sheriffs. Austin: Texas Monthly Press, 1988.

Tise, Sammy. Texas County Sheriffs. Hallettsville, Tex., 1989.